You Can Paint
Vibrant
Watercolors

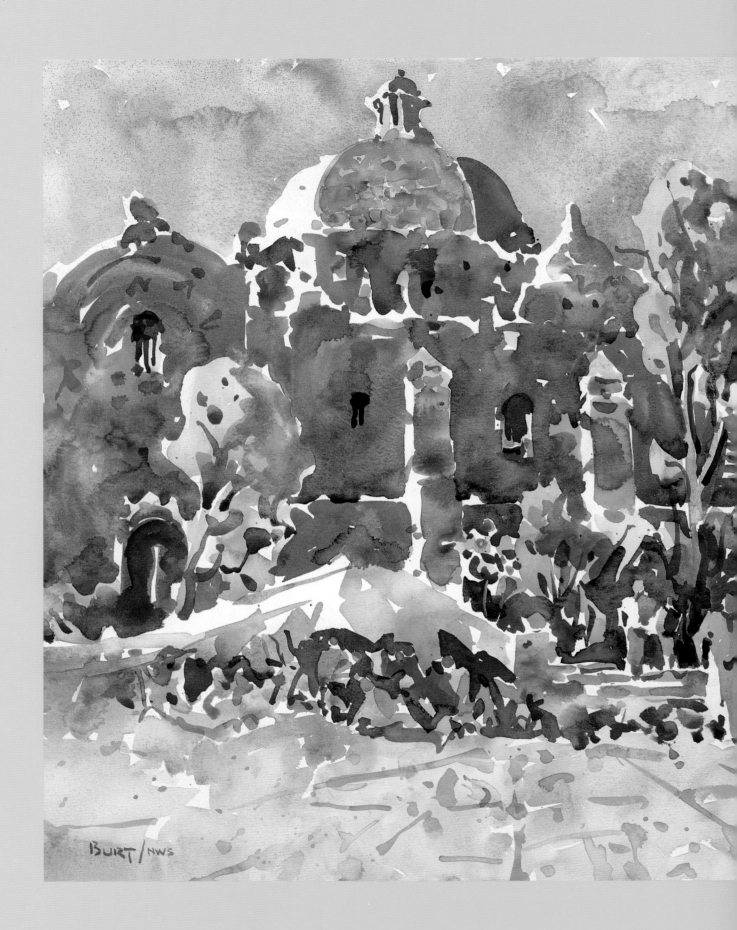
BURT/NWS

You Can Paint
Vibrant
Watercolors

Dan Burt

THE MEXICAN BALLONISTS
22″×30″ (56cm×76cm)
Watercolor on Arches 140 lb. (300gsm) cold-press
watercolor paper

NORTH LIGHT BOOKS
CINCINNATI, OHIO

This book is dedicated to my wife, Anne.

You Can Paint Vibrant Watercolors. Copyright © 1999 by Dan Burt. Manufactured in China. All rights reserved. No part of this book may be reproduced in any form or by any electronic or mechanical means including information storage and retrieval systems without permission in writing from the publisher, except by reviewer, who may quote brief passages in a review. Published by North Light Books, an imprint of F&W Publications, Inc., 1507 Dana Avenue, Cincinnati, Ohio 45207. (800) 289-0963. First edition.

This hardcover edition of *You Can Paint Vibrant Watercolors* features a "self-jacket" that eliminates the need for a separate dust jacket. It provides sturdy protection for your book while it saves paper, trees and energy.

Other fine North Light Books are available from your local bookstore, art supply store or direct from the publisher.

03 02 01 00 99 5 4 3 2 1

Library of Congress Cataloging-in-Publication Data

Burt, Dan.
 You can paint vibrant watercolors / by Dan Burt.—1st ed.
 p. cm.
 Includes index.
 ISBN 0-89134-903-0 (hardcover: alk. paper)
 1. Transparent watercolor painting—Technique. I. Title.
ND2430.B87A4 1999
751.42′2—dc21

98-49886
CIP

Edited by Michael Berger
Production edited by Jeff Crump
Interior designed by Angela Wilcox
Cover designed by Mary Barnes Clark
Production coordinated by Erin Boggs

About the Author

Dan Burt paints in Texas, Louisiana, Mexico, Italy and Spain using transparent watercolor. His impressionistic style reflects his enthusiasm. With rich color and deep feeling, he creates paintings which he calls "imaginationscapes" full of life and spirit.

Photo by Dr. Cynthia Blasingham

He has conducted workshops and given painting demonstrations in Texas, Oklahoma, Arizona, Indiana, Louisiana, California and central Italy. He has also juried numerous exhibitions. In 1996 he served on the jury of selection for the 129th Annual American Watercolor Society International Exhibition in New York, NY. In 1998 he served on the jury of selection for the 78th Annual National Watercolor Society Exhibition in Fullterton, California.

Burt has won over seventy awards in national, regional and state juried exhibitions. These awards include five gold medals, two silver medals, three awards of excellence and nine best of shows. His work has been included in ten books and featured in six magazines. He is an elected signature member of the American Watercolor Society, National Watercolor Society, Allied Artists of America, Audubon Artists, Watercolor West, the Rocky Mountain National Watermedia Society and the Texas Watercolor Society. He was elected to the board of directors of the American Watercolor Society for 1997 and 1998. His work is in numerous public and private collections.

Acknowledgments

I give thanks to God without whose help I could not have done this book or anything else. Thanks also to my wife Anne and my daughter Barbara for encouraging me to paint; to my parents Catherine and Harold Burt for supporting me in this effort; to my early mentors Joi Carrington and Simon Michael who instilled enthusiasm and the right attitude; to Jane Wood for typing the manuscript and last but not least the staff at North Light Books, especially Michael Berger, Pamela Wissman, Jeff Crump and Rachel Rubin Wolf.

Table of Contents

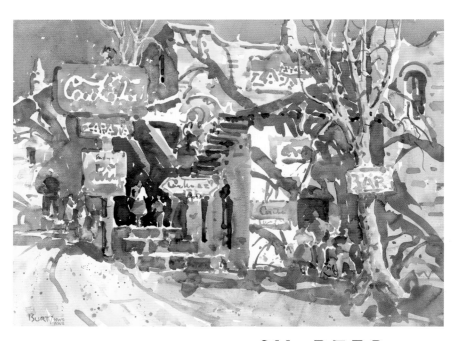

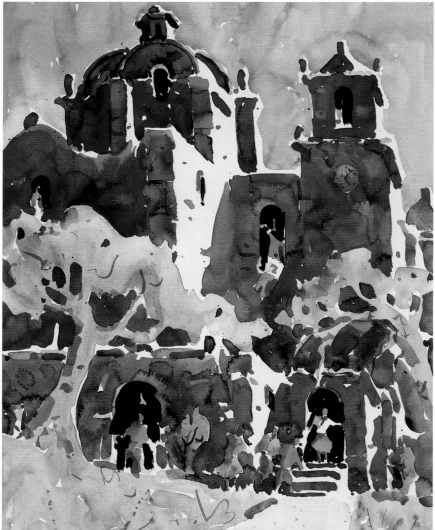

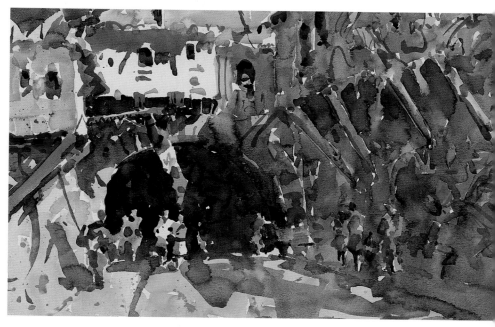

CHAPTER 3
Design

Elements and principles of design illustrated in bright colors, including good/bad comparisons, pattern schemes, composition schemes, how to combine them.... 46

CHAPTER 4
Putting it All Together—
Demonstrations

Step-by-step demonstrations that show the process to the full extent of what is taught in the book, from concept thru design principles and composition schemes to color schemes, and then on to painting from light to dark.... 74

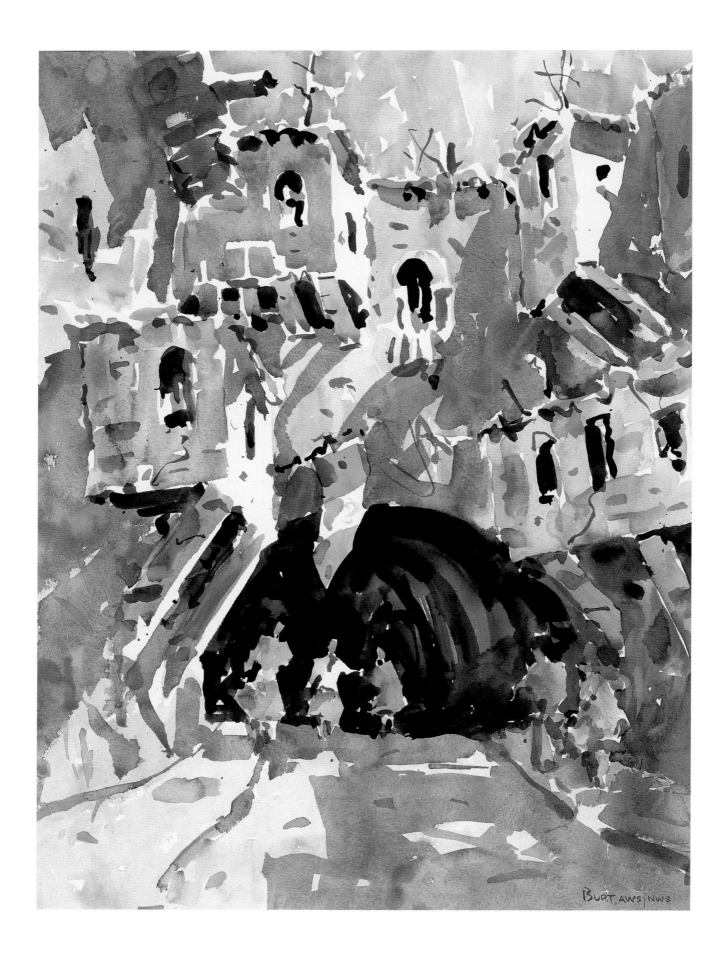

INTRODUCTION

This book is about painting with pure, clean, vibrant, transparent watercolor with a simplified approach. It's designed for beginners, advanced beginners, intermediates and even advanced watercolorists who want cleaner and more vibrant color. It's also written for watercolorists who want to loosen up and have more fun. Edgar Payne once said, "Pleasure in depiction is one of the objectives in painting." This book is about that pleasure.

With this book, you will learn how to make good compositions with better shapes and directions. You'll see how I go about painting using architectural subjects such as buildings, churches and boats as models. You'll learn how symbols for figures, trees, flowers, mountains and so forth, are incorporated into paintings for interest. And you'll learn how to establish a focal point and go about gathering concepts for your paintings.

This book will teach you through progressive, four-stage, light-to-dark demonstrations. These demonstrations will illustrate focal points, high-chroma (intense) colors with opposites, saved whites, values, shapes, directions, texture, composition, readability, lucidity of statement and effect. You will learn how to paint using pigment puddles and a simplified palette. And hands-on exercises will show pure, clean colors allowed to mix on paper, as well as the vibrancy and vibration of colors not allowed to mix. Painting should be entertaining, and all of the above are means to that end. Keep painting and have fun!

CALLEJON IV
Watercolor on 140-lb. (300gsm) cold-press paper
30″×22″ (76cm×56cm)

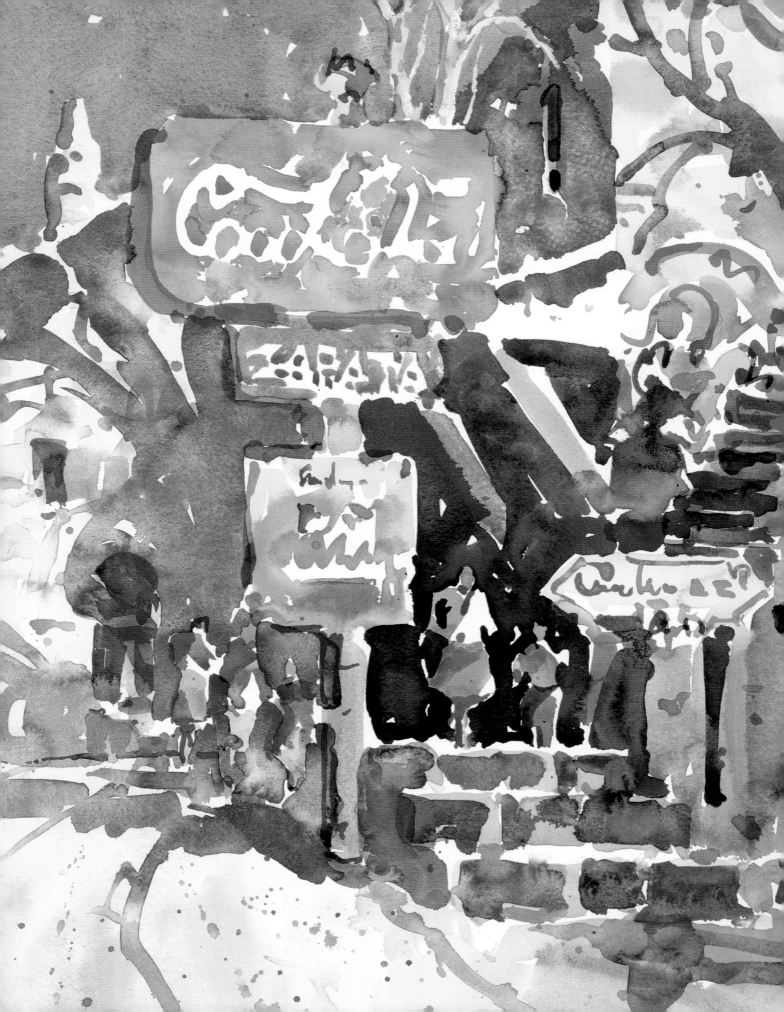

CHAPTER 1

Getting Started

Starting to paint watercolors that are vibrant, clean and pure is fun and exciting. Though there is a wide range of materials and equipment available, you'll be able to limit your materials to the essentials. You'll find that by focusing on just the pure, clean colors you can create watercolors that are visually fulfilling, exciting and vibrant!

SIGNS OF THE TIMES
22″×30″ (56cm×76cm)

Tools and Materials That Make Painting More Fun

Paints

There are many brands and colors of paint available. The paints I use most frequently are Da Vinci brand Permanent Rose, Aureolin, Viridian, Cobalt Blue, Ultramarine Blue and Phthalo Green; Winsor & Newton brand Cadmium Yellow, New Gamboge, Winsor Yellow, Cadmium Scarlet and Permanent Alizarin Crimson; and Holbein brand Opera. These colors are available in other brands but you might have to spend more.

> Painting is a matter of relaxing to the pleasurable influences of your imagination and emotional impulses.
>
> — EDGAR PAYNE

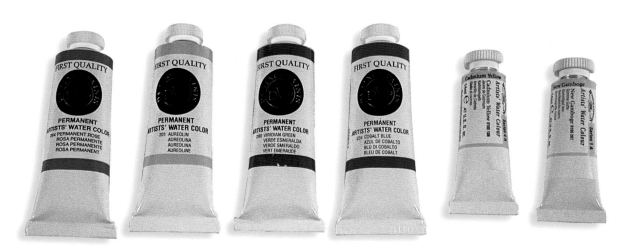

| Permanent Rose | Aureolin | Viridian | Cobalt Blue | Cadmium Yellow | New Gamboge |

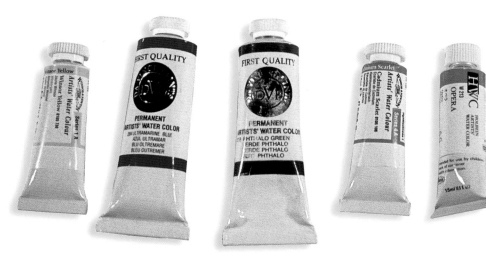

| Winsor Yellow | Ultramarine Blue | Phthalo Green | Cadmium Scarlet | Opera | Alizarin Crimson |

Paper

I usually use Arches 140-lb. (300gsm) cold-press, 300-lb. (640gsm) cold-press or 140-lb. (300gsm) hot-press watercolor paper. Use 140-lb. (300gsm) if you're intimidated by the cost of the 300-lb. (640gsm). My personal favorite is Arches 140-lb. (300gsm) cold-press, which I use 90 percent of the time because of the way it accepts the paint. It has very little sizing (a material applied to the surface of the paper to provide resistance to liquid penetration). The lack of sizing allows wet colors to grip the paper yet move around and blend with other wet colors. It has a medium tooth (the texture that helps it hold the paint), but it's not too rough. If you use the 300-lb. (640gsm) paper, remove the sizing first with a flat house-painting brush and clean water.

Hot-press paper has no tooth, so you can't tilt your drawing board very much or the paint will run off. It does have a slightly different set of magic accidents that it performs during wet-on-wet painting (*placing a wet stroke on dry paper, then another next to and touching the first before the first dries, making a wet-on-wet mixture*) because the color floats around on the surface. I also like Waterford and Fabriano 140-lb. (300gsm) and 300-lb. (640gsm) cold-press because of the magic accidents they perform when allowed.

Tips

- Beware of staining colors. Staining colors (pigments that tint the fiber of the paper) won't scrub out on Arches paper, so don't try it. Besides, scrubbing muddies color, and that's no fun!
- You can paint on both sides of your paper if things don't work out the first time, which does happen in this line of work. I should know, since it's happened to me plenty of times!

Definitions

MAGIC ACCIDENT A mishap or unexpected happening that results in an effect you really like, but would never have tried up front.

Brushes

I use nos. 6, 8, 10 and 12 round brushes; a rigger or liner (both are small with long hairs); and 1-inch (2.5cm), 1¼-inch (3.2cm), 1½-inch (3.8cm) and 2-inch (5.1cm) flat brushes. I also use a no. 5, 6 or 7 small oil-painting brush with short, flat, worn-down bristles (cut them off if they're not short). I try not to use the oil brush much, but it's a last resort for scrubbing out very small areas about ¼-inch (6.3mm) in diameter.

All my brushes are sable, except for the 2-inch (5.1cm) flat brush, which is squirrel or ox hair. Ox, camel and squirrel are good substitutes for the more expensive sables because, like sables, they hold a lot of water. My sable brushes are not very pretty. Someone once told me they look like roadkill, but they still hold a lot of water and pigment and continue to perform well. I wash them with soap and water occasionally.

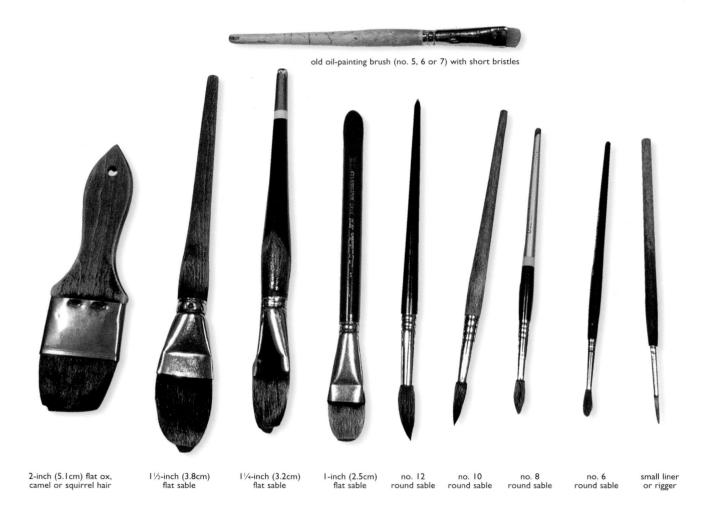

old oil-painting brush (no. 5, 6 or 7) with short bristles

| 2-inch (5.1cm) flat ox, camel or squirrel hair | 1½-inch (3.8cm) flat sable | 1¼-inch (3.2cm) flat sable | 1-inch (2.5cm) flat sable | no. 12 round sable | no. 10 round sable | no. 8 round sable | no. 6 round sable | small liner or rigger |

Palettes and Cups

I use one Robert E. Wood palette and two John Pike palettes. The Robert E. Wood palette, which is white and nonporous, is just for the wells that hold the pigments (you can substitute another brand as long as it has deep wells). The two John Pike palettes are for the puddles, which I'll talk about in chapter two. Any flat, white, nonporous surface can be substituted for these.

When I'm painting outdoors where the ground might not be level, I use eight plastic cups in addition to the palettes. The cups should be white or clear so you can see the color of the paint. Plastic butter or margarine containers work well and have lids so you can save what's left.

Water Bowls and Buckets

I use two water bowls for outdoor painting and two buckets while in the studio: one for cleaning brushes, the other for painting. Get clear or white plastic bowls and buckets so you can easily see how clean or dirty the water is. I put the bowls on TV trays for outdoor painting, so the bowls can't be too large. For the studio, get two buckets or other large water receptacles and start each session with clean water. Starting off this way saves you the trouble of having to change your water during a session, and it can also douse any fires that happen to break out in the studio!

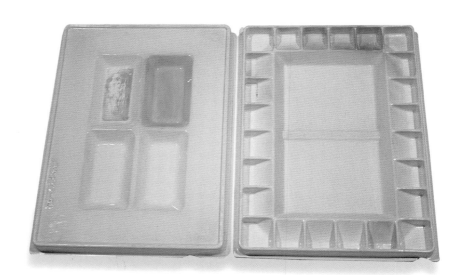

Your Palettes
Use the top and bottom halves of the Robert E. Wood palette (right) with its deep wells for your pigments, and the top and bottom halves of the two John Pike palettes (bottom) for your color puddles.

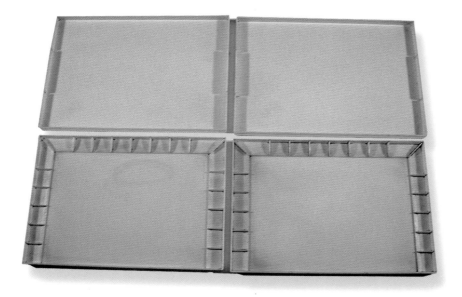

Stick 'Em Up!

Use little bits of a kneadable product called Stick-up (found in variety, craft and school supply stores) to hold your plastic cups to a TV tray or palette. One time when I was painting in Rockport, Massachusetts, I didn't stick my cups down and the wind blew them all into the Atlantic ocean—that was very discouraging.

Sketching Materials

I prefer a smooth Grumbacher pad for pen and ink because it has no tooth, like hot-press watercolor paper. It is also suitable for brush washes in ink or watercolor. I use Pilot Precise V5 Rolling Ball pens in fine or very fine—these pens glide effortlessly over the slick paper. Other options are soft sketching pencils, like a 6B, or, with sketch pads that have tooth, charcoal (pretty messy). Make sure your pencil tips are well rounded so they don't gouge the paper. Keep a kneadable eraser handy to pick up unwanted pencil lines when you're finished with the painting.

Spray Mist Bottle and Paper Towels

A spray mist bottle is an optional item, but it is a useful thing to have. Give the puddles and the paint in the wells an occasional squirt to keep them moist. (The bottles also make excellent water pistols for giving onlookers and critique pests a squirt if they get too close.) I mostly use Bounty paper towels for cleanup and for drying my sable brushes, and for a not so occasional blot. Any strong and absorbent brand will work.

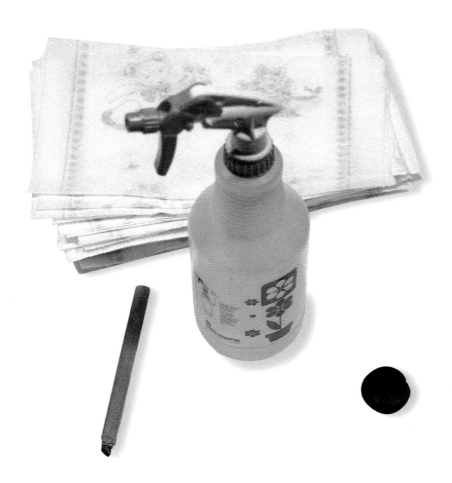

Always Be Prepared
Keep your mist bottle and paper towels close by. I use the towels for the not so occasional blot, and the mist bottle to keep colors and puddles moist.

Easels and Clips

Easels give you freedom of movement, allowing you to loosen up and be more creative. I recommend using a portable, metal watercolor easel that adjusts to different heights and tilts to any angle for both studio and on-location painting. The one shown here was made in Italy and, though twenty-five years old, is still quite stable. It's no longer made, but there are several others now on the market that are as good or better. Buy yours from your local art supply store, or order one from a discount catalog. Make sure it will hold a full 22″×30″ (56cm×76cm) watercolor sheet vertically. Though you want one that is easy to transport, I personally don't recommend an aluminum easel. It's lightweight, alright, but not very stable.

Use clips to attach your paper to your drawing board. You'll need four clips when outdoors in the wind but only two when working in the studio.

TV Trays

I use a couple of folding TV trays to hold my palettes, cups, brushes and water bowls when I work outdoors. Some I bought from a discount store, while others came from garage sales. Stick your palettes and cups onto them with Stick-up (a kneadable adhesive available at craft, variety and school supply stores—it'll stick to anything so long as it is clean) so they don't blow away. You can get by without TV trays if you paint sitting on a camp stool, but bear in mind all of your equipment will then be on the ground.

Hair Dryer

Though not a must, a hair dryer is nice to have when I'm doing a demo and I want to dry a section quickly before I go on to the next one. I don't usually use it in the studio, because it buckles the paper more and ruins soft background music. Naturally, you don't need it outdoors.

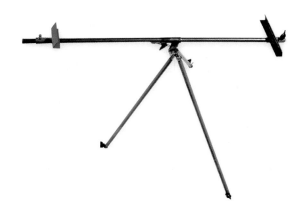

Your Easel
Find yourself a strong, stable easel that will hold a full 22″×30″ (56cm×76cm) sheet of watercolor paper. Make sure that the one you choose will be sturdy enough for fieldwork—the last thing you want is for your easel to blow over while you're working! At the same time, make sure it is not so heavy that it is difficult to transport.

Keep Your Paper Down
Clips are great for holding your paper during a sketch or for painting in windy conditions. You'll need four of these if you work outdoors, but only two in the studio.

What Should I Paint?

Now that you know what equipment and materials to use, the question turns to what to paint. Pick a subject that interests you personally. It might be a shape, conflict in the direction of lines, value contrast, color contrast, texture or color intensity that excites you. Your preferences cause you to choose one shape or subject over something else.

Take Pictures

Photos and slides can be good points of departure for paintings if you can make artistic interpretations of them. The problem with photos is that cameras record everything in front of the lens with equal importance, so don't copy the photos literally in your paintings. However, if you can edit the photos in the same way that you would edit your sketches, photos can be use-

Never Give Up!

Don't be discouraged if a painting doesn't work out. It's all part of the natural process of being a watercolorist. I've had plenty of failures. My wastebaskets have been full of them for years; some were so bad that I had to work on them to make them good enough to throw away!

ful. I prefer my on-location sketches to photos because I can be more selective in what I put in the sketch. Remember that cameras don't have imagination, intuition, memory, judgment, enthusiasm, talent or intelligence—only you do.

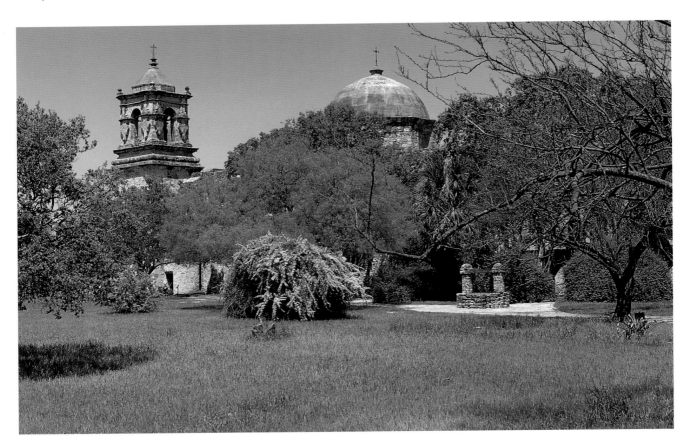

Don't Be a Slave to the Photograph
You wouldn't have a very exciting design if you used this photograph for your model. The church is obscured by the trees, which are almost all the same value and color. The bell tower and dome are about the same value and color as well, and they are almost on the same height. The middle values of the sky and foreground have no gradation in value or color. Definitely a boring composition!

Sketch On-Location

You don't have to go to Europe for ideas. You can find them in your hometown, the next town over, your imagination or your memory. Use soft pencils, fine-tipped or broad-tipped pens, and any type of sketchbook you're comfortable with. Sketch what you like. Be receptive to contrasting lines, values, colors, textures, sizes and shapes. Make value drawings that show whites, middle values, darks and darkest darks. Or make line drawings with no values. Either way, these drawings trigger ideas and give you freedom to make choices. Make more than one sketch—the next one might be better. Add, delete, rearrange and take liberties with elements to get good designs. Make brush washes or use watercolor in only three colors—red, yellow and blue. Try Alizarin Crimson, Ultramarine Blue and New Gamboge.

Adversity Builds Character

Once when I was painting in Guanajuato, Mexico, a group of juvenile delinquents gathered around my easel. They began to hassle me and disrupt my painting. They kept it up for awhile, so I decided to fold up my tent and finish the painting back at the motel. Suddenly, for some reason, I started this loud coughing. They all scattered like quail—must have thought I was tubercular. I don't recommend using this technique for getting rid of people, however, as they might start coughing on you! The moral of the story is that adversity builds character, and painting requires character.

2. middle value 1. light or saved white 4. darkest dark 3. dark value

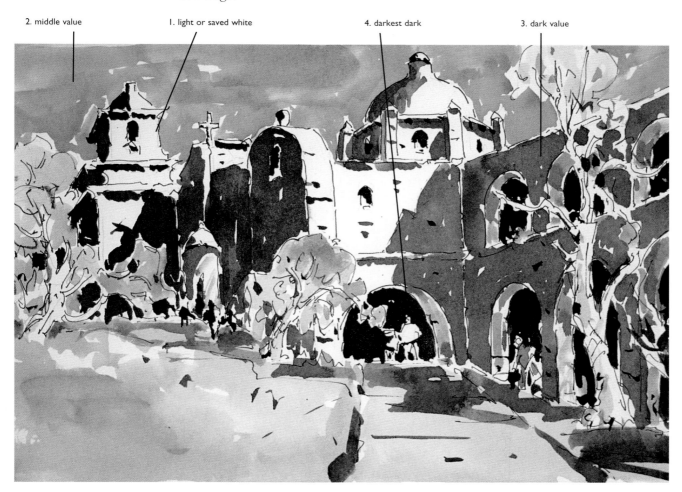

Value Drawings
Make a four-value pen-and-ink sketch showing whites or lights, middle values, darks and darkest darks.

Paint On-Location

Plein air painting (working directly outdoors from observation) is my favorite option for getting my creative juices flowing and getting new ideas. Sometimes it's best to just go to a location and start painting whatever catches your eye.

The act of painting itself can cause visual stimulation, excitement and enthusiasm. Don't do what I did when I first started on-location painting. I spent all day looking for the ideal shape, color and direction. I drove until I almost wore the car out. Remember that the ideal doesn't exist except in your imagination. Spend your time painting, not driving. See with your mind's eye—with your imagination. As Frank Webb would say, "Do not paint what is; paint . . . what ought to be."

Use the Muse

Daydreams and other art forms can trigger ideas. For example, I'm one of those people whose imagination is stimulated by music while painting. One art form enhances another, and apparently it can work both ways. The Russian composer Modest Mussorgsky (1839-1881) wrote the classical masterpiece *Pictures at an Exhibition* after being influenced by a painting exhibition. Claude Cheek from Fredericksburg, Texas, told me about a college football team that was put in a quiet room and asked to do a creative project. They did miserably. The very next day, they were asked to repeat the process while classical music played softly in the background. They all did much better.

The key to your selection of what to paint is your enthusiasm; you will paint best what you like best. Sketching, photographing, painting on location, painting in the studio with soft music, daydreaming and imagining are only means to an end. That end is to get ideas and get excited about a subject. Be persistent and don't quit. Painting is a long, pleasant journey. Don't try to complete the journey in one day. Enjoy the means one day at a time and you will be rewarded with the end—a wonderful, accidental surprise when you least expect it.

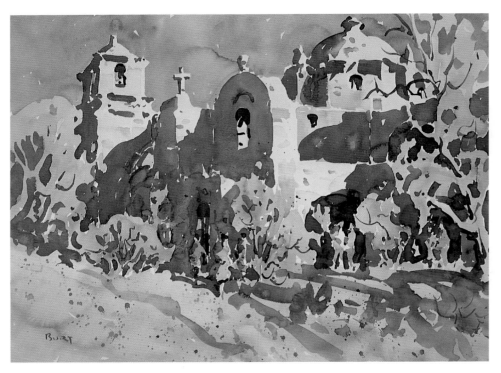

Take Liberties
This painting is certainly an improvement over the sketch and a big improvement on the photo. If you compare, you can see that I took many liberties. The painting has unequal measures and variety in line, value, color, texture, size, shape and direction. It also has a well-defined focal point (the figures framed by the darkest darks in the lower right).

SAN ANTONIO TOURIST TRAP
22" × 30" (56cm × 76cm)

TROPICAL DERELICT
22″×30″ (56cm×76cm)

Ask First, Then Have a Good Day

Outdoor painting provides stimulation, but it's not without its hazards. Once I was painting a few feet off a public road on private property. The owner came by and said he was going to get his shotgun and hoped I'd be gone when he returned. I usually clean up slowly and meticulously, but I made an exception that time and set a record for cleaning up. On another occasion, the property owner turned out to be the county judge, who threatened me with jail. Always ask permission to paint if you can find the property owner. Once I got permission to paint as long as I didn't take over fifteen minutes. Instances like these can ruin your day, but they're all part of the painter's learning experience.

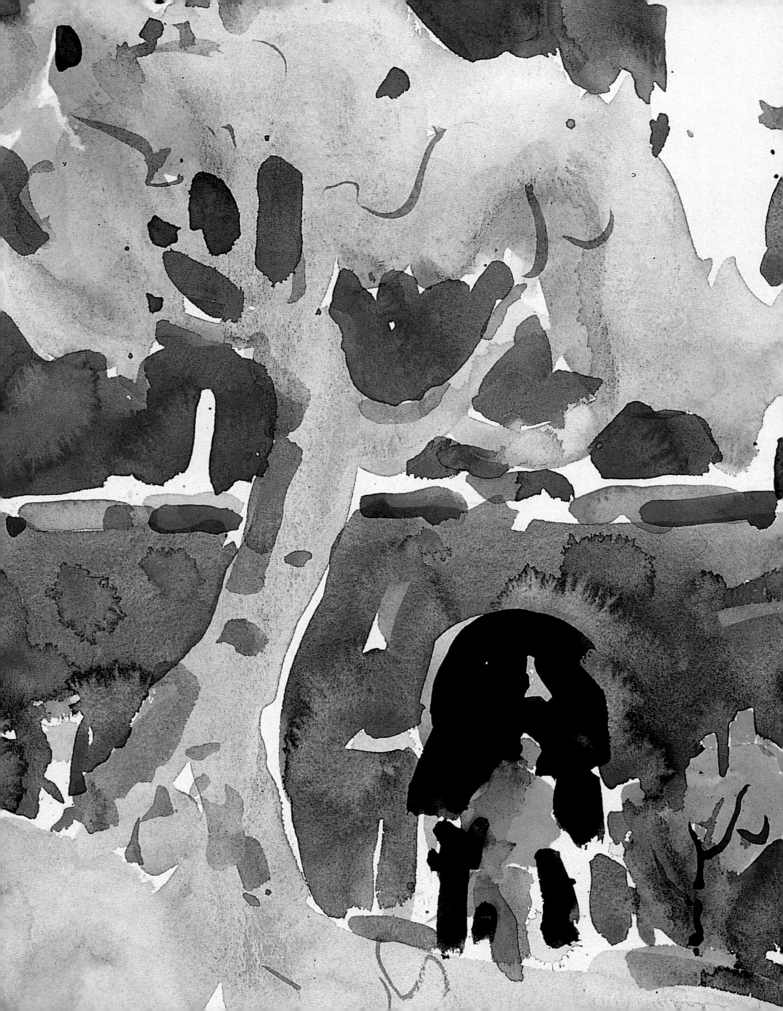

CHAPTER 2
Techniques for Pure, Clean Color

Technique is important for expressing feelings, emotions and ideas. Everyone eventually develops their own technique unless they're copying someone else's style, but in the words of Al Brouillette, that's about as exciting as reading the telephone book or coloring a coloring book.

Watercolor is very fragile and doesn't take kindly to being overworked. When I first met this wonderful medium, I wanted to be in control at all times. I was afraid to take risks, and the results were disastrous. I ruined many sheets of paper, and I was not having fun. I finally learned to let the paint do what it wanted in large parts of the painting and to leave it alone. Now, I'm afraid to *not* take risks, and I'm rewarded frequently with beautiful accidents when I least expect them. There are still failures, of course, but that's normal. This beautiful lady called watercolor has a mind of her own, but she will perform miracles if you let her.

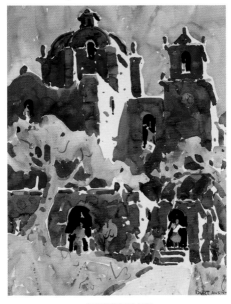

MEXICOSCAPE
Watercolor on Arches 140-lb. (300gsm) cold-press watercolor paper
30″×22″ (76cm×56cm)

Setting Up Your Palettes

As I outlined in chapter one, use one Robert E. Wood palette to hold your pigments and two John Pike palettes for your puddles of pigments dissolved with water. Keep the puddles separate, and don't allow them to mix on the trays. Some workshop people I have met not only don't keep their paints separate, they let them get hard until they're more like cement or stone—more suitable for sculpture class than wa-

tercolor. Perhaps those people have found a way to shape the dried-up paint using hammers, chisels and sharp knives. Remember that once watercolor becomes hard and dried out, it can't be made fresh and pliable again even if you put water on it and let it soak for a month. Fresh, supple, wet paint performs. Dry, hard paint doesn't.

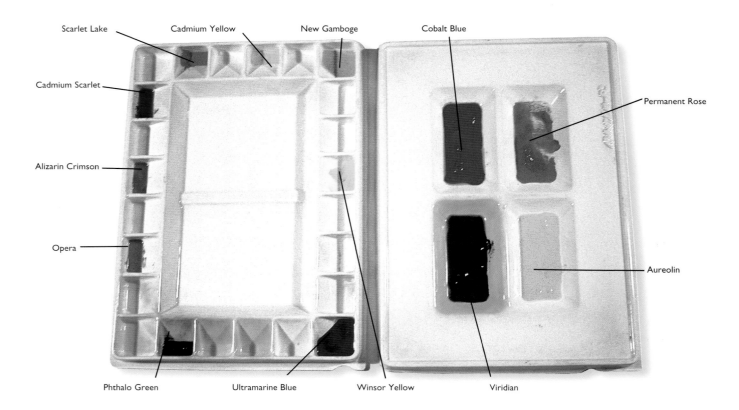

Wells

Keep your paints fresh, clean and wet. Squeeze out Permanent Rose, Aureolin, Viridian and Cobalt Blue into the four top compartments as shown above. Put Cadmium Scarlet, Scarlet Lake, Cadmium Yellow, New Gamboge, Winsor Yellow, Ultramarine Blue, Phthalo Green, Opera and Alizarin Crimson in the wells of the bottom half (the paints can be kept cleaner by skipping well spaces). Squeeze out a little more than you need for each painting session. Clean the wells of the pigments at the end of each session by putting clean water in the wells, tilting the palette and absorbing sullied color with a paper towel.

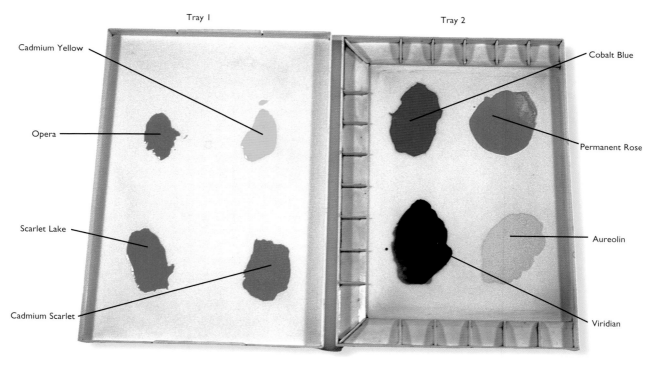

Tray 1

Cadmium Yellow

Opera

Scarlet Lake

Cadmium Scarlet

Tray 2

Cobalt Blue

Permanent Rose

Aureolin

Viridian

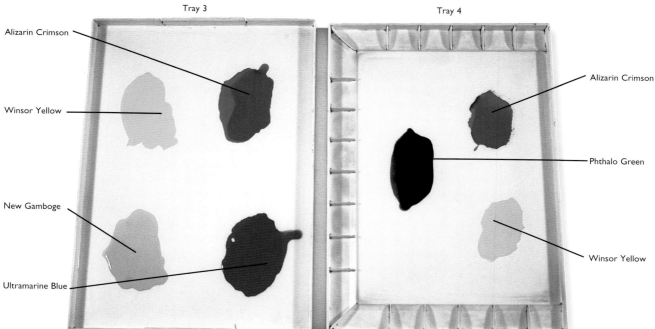

Tray 3

Alizarin Crimson

Winsor Yellow

New Gamboge

Ultramarine Blue

Tray 4

Alizarin Crimson

Phthalo Green

Winsor Yellow

Puddles

Take clean pigments from the Robert E. Wood palette wells and dissolve them into separate puddles on the four trays of the two John Pike palettes as shown. Use clean brushes and clean water. Make sure the pigment is fully dissolved and your puddles are on the rich side. It's easier to make them leaner by adding more water than it is to make them richer by adding more pigment. Replace the puddles as they are depleted.

Using Trays 1–4: Example 1

This small painting, though it bears little resemblance to the actual scene, was the result of seeing old buildings grouped together in the mountain town of Ronda in southern Andalucia, Spain. It's a good example of trays 1 through 4, though saved whites and saved colors play a major role. Tray 1, with its intense color with opposites, was used for figures, cars, roofs and small pieces of color on the saved whites of the buildings. Tray 2, middle values, was used for trees, sky and foreground. Tray 3, dark values, was used for the buildings, cast shadows and curb. Tray 4, the darkest darks, became trees, windows and doorways.

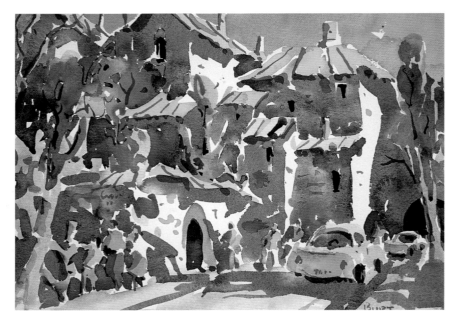

ANDALUCIAN SHADOWS
11″×15″ (28cm×38cm)

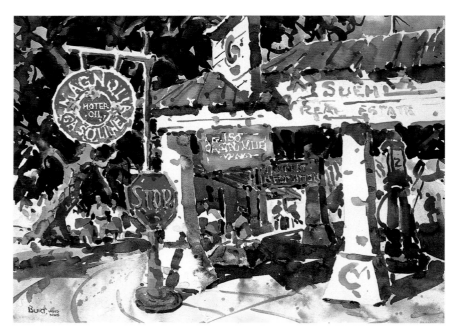

FULL SERVICE IV
22″×30″ (56cm×76cm)

Using Trays 1–4: Example 2

This painting is another good example of using trays 1 through 4. Tray 1 is used for the intense colors with opposites as seen in the figure and sign. Tray 2 makes up the midrange values of the sky, foreground, tree trunk and blue shadow on the figure. Tray 3 is used for the darks of the filling station, shadows and curb. Tray 4 is used for the darkest darks of the tree, buildings and doorways. Notice how saved whites play a major role.

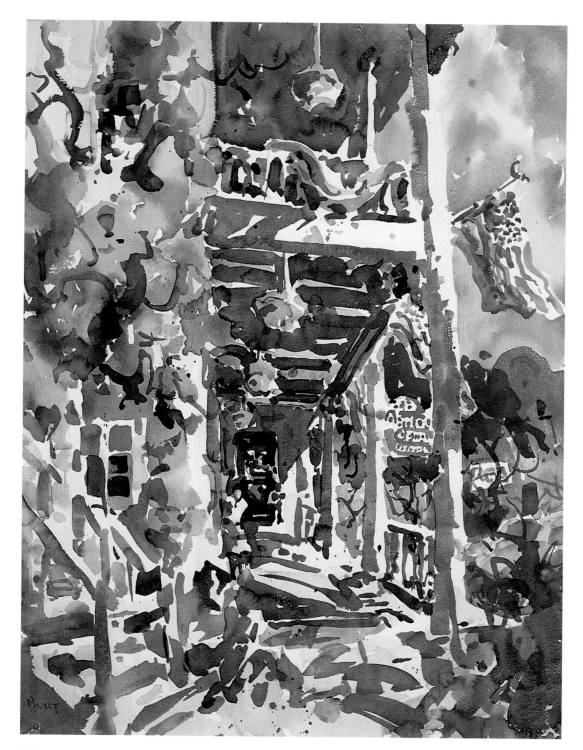

Using Trays 1–4: Example 3

Bed and Breakfast is yet another example of using trays 1 through 4. Intense colors from tray 1 were put down first and not allowed to mix, as seen in the figures, flags, signs, etc. The midvalues from tray 2 were used in the foliage, sky, small foreground and sunlit side of the building and were allowed to mix wet-on-wet. Tray 3 was used for the darks, and tray 4 was used for the darkest dark of the doorway behind the figure.

BED AND BREAKFAST
30″ × 22″ (76cm × 56cm)

Earth Colors: No!

I used to use earth colors a lot in painting. I mixed Burnt Sienna, Burnt Umber and Raw Umber with blues to make darks and grays, and I mixed Raw Sienna and Yellow Ochre with pure colors to gray them. I knew my colors were blah, anemic and muddy, but old habits die hard. Finally, I had had enough. Ironically, it was an oil painting class that made me see the light. I learned that you can approximate any earth color with pure color and it looks much cleaner. This became doubly true for watercolor. My watercolors became cleaner, more transparent and much more vibrant. The grays had more sparkle, vitality and color.

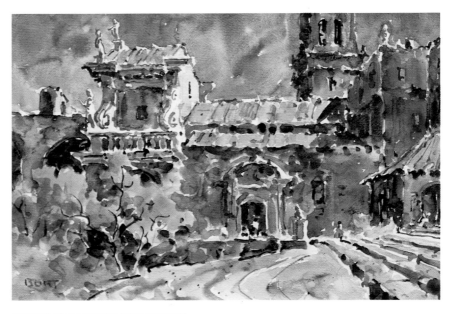

CHURCH OF SAN FRANCESCA ROMANA
21″×14″ (53.5cm×35.5cm)

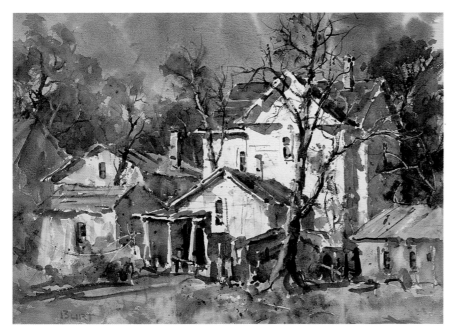

LOUISIANA HOUSESCAPE
30″×22″ (76cm×56cm)

Problem—Earth Color

Both of these paintings, done in 1981, have a real problem: Burnt Sienna and Burnt Umber were used with blues to make grays and darks. Of the two, the *Church of San Francesca Romana* (top) is a better painting with better shapes, sizes and directions. It even has a semblance of color balance. However, it is the muddier of the two. *Louisiana Housescape* (left) ended up about the same—muddy darks and grays. Even the trees are muddy! There is too much saved white in the house to have a pronounced focal point. There is no vibrancy in either painting.

Solution—No Earth Color

The solution is obviously no earth color. Both of the paintings you see here have vibrancy, color balance, color contrast and vitality because they haven't been muddied up with earth color. The darks and darkest darks in these paintings are made with Phthalo Green mixed with Alizarin Crimson, and Ultramarine Blue mixed with Alizarin Crimson. Small amounts of other colors such as Winsor Yellow, Cadmium Yellow and Cadmium Scarlet were dropped into those dark wet mixtures.

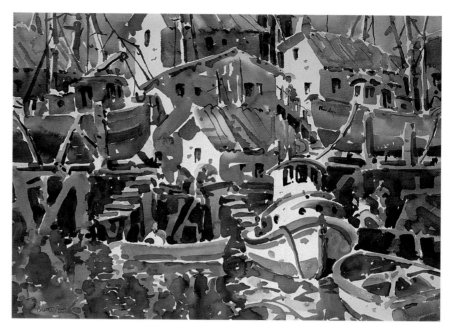

GLOUCESTER DREAMSCAPE I
22"×30" (56cm×76cm)

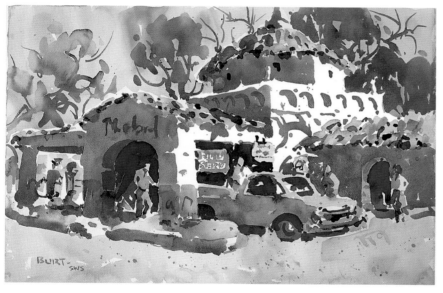

ALAMO HEIGHTS FULL SERVICE
15"×22" (38cm×56cm)

Earth Tones Ruin Color!

In an outdoor watercolor class once, a participant walked by, looked at my work and said, "That Burnt Umber just ruins everything it gets into, doesn't it?" That about sums up the effect of earth colors.

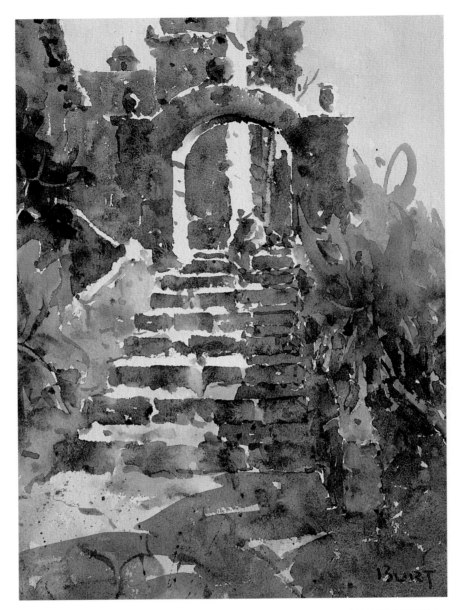

Problem—Earth Color

Ironically, this painting is not too bad. The shapes, directions, sizes and values have variety, contrast and interest. It shows spontaneity and a willingness to take some risks. The color, however, leaves something to be desired. It's Burnt Sienna throughout—by itself in places, mixed with yellow for the sky and foreground and mixed with blue for darks and grays. There is no real color balance; that is, a large amount of a color with a small amount of its opposite or vice versa. There is color harmony, but it's almost monochromatic. The color has no vibrancy. It has come close to being muddy where the Burnt Sienna mixed with the blue. This was my last watercolor done with any earth color.

MAN OF PAPANTLA
15″×11″ (38cm×28cm)

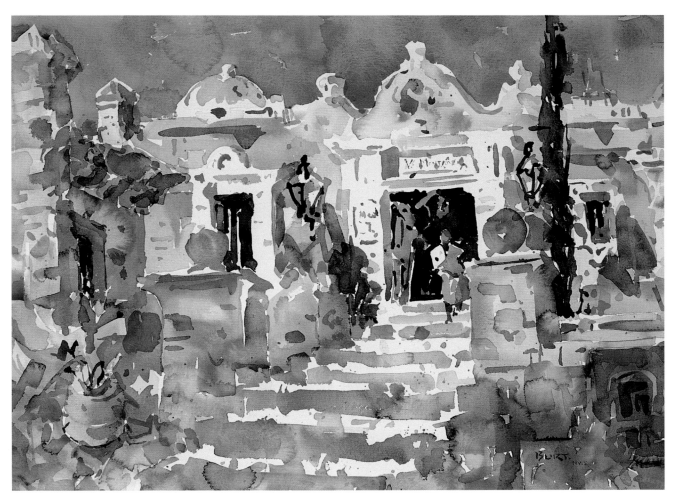

Solution—No Earth Color

This painting is not perfect. It's a little muddy in the dark at the lower right corner. Overall, however, it is a huge improvement because it uses pure color, but no earth color.

AT THE VILLA MONTANA
22″×30″ (56cm×76cm)

Painting-Technique Exercises

Someone once said that if you are self-taught, then you had an idiot for a teacher. I don't agree. Experience is always the best teacher, and there is no substitute for it. Don't be afraid to make mistakes as you go along. You can attend workshops from now until doomsday, and that's good, but in the end, you will learn more from your own mistakes.

So with that in mind, let's get started! Working from dissolved puddles on the trays, use a big, flat 1½-inch (3.8cm) brush. Have plenty of clean water, and clean the brush after each stroke to get accurate results. Use a full 22″×30″ (56cm×76cm) sheet of cold-press paper. Remember, if things don't go the way you would like, you can always use the other side. Start at the top left of the paper, and make each shape about five or six inches (12.7 or 15.2cm) square. These experiments will get you acquainted with the pigments, what happens when you let them mix wet-on-wet and what happens when you don't. Do more than one of each exercise as it is good practice. Use different water-to-pigment ratios each time, and notice the different results.

Don't Let Them Mix: Combinations of Opposites

This exercise illustrates the maximum color impact and vibration of pure colors with their opposites when they are not allowed to mix. Use this scheme for figures or any other shape when you want to get the viewer's attention. Let each color dry before you put it's opposite next to it, or leave a space so they don't touch.

A Put down Cadmium Scarlet with a touch of Cadmium Yellow from tray 1. Put down Cobalt Blue from tray 2. Remember to not let them mix.

B Put down Cadmium Scarlet with Opera in it from tray 1. Place Phthalo Green from tray 4 next to it.

C Put down Cadmium Yellow from tray 1. Place Ultramarine Blue with Opera, both from tray 3, next to it.

D Put down Cadmium Yellow from tray 1. Place Cobalt Blue with Permanent Rose, both from tray 2, next to it.

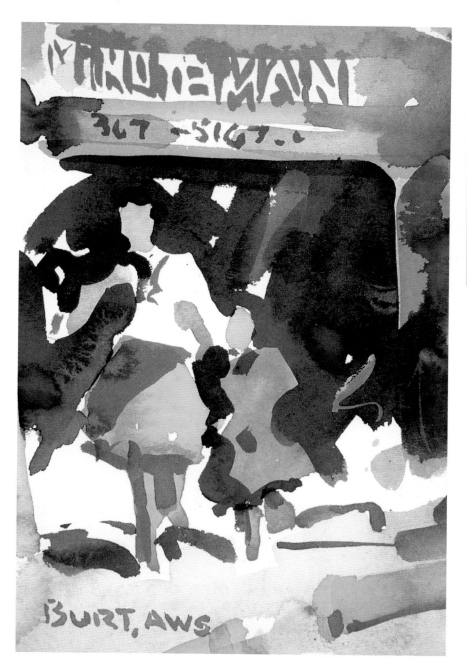

Details of Paintings

These two details of paintings demand the viewer's attention. The colors are pure and clean, and the saved whites add to the impact. Add to that the fact that the saved whites are pushed out by the darks behind them, and they suddenly become impressive.

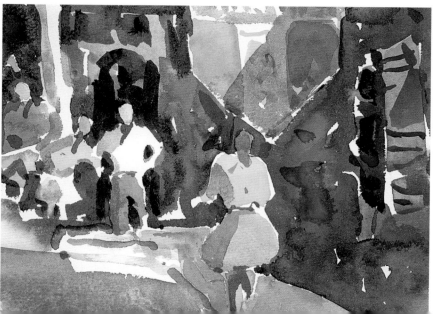

Let Them Mix: Combinations From Tray 2

Tray 2 is used predominantly for middle values such as the sky, foreground, etc. Use all four colors from this tray wet-on-wet. Make two or three examples of each, experimenting with both rich and lean combinations. Use just one brushstroke for each color, and keep the paint wet. Don't overwork the paint, and watch the magic granulations as the colors dry.

2. Permanent Rose I. Aureolin 3. Cobalt Blue 4. Viridian

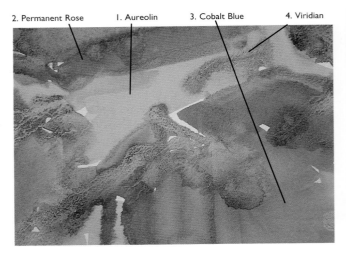

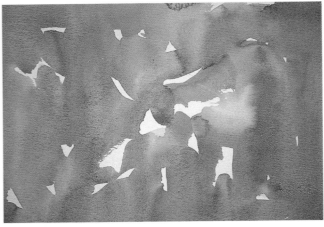

Wet-On-Wet Mixing

Make some strokes of rich Aureolin. Put rich strokes of Permanent Rose next to it. Put down Cobalt Blue and finally, rich Viridian. Notice what happens with the Permanent Rose. It doesn't move around and mix well with the other colors because it's too rich.

Midrange Values

Using the same colors, but this time on the lean side, repeat the previous exercise. Notice what a good job Permanent Rose now does in mixing with the other colors in a lean state. Use this combination for midrange values such as sky, foreground, light trees, figures, etc.

Sky and Water

Use Viridian and Cobalt Blue mixed wet-on-wet for the sky, water, etc. It makes a nice granulated blue-green aqua color—another good midrange value color (the sample on the right has more Viridian and shows more granulation).

Buildings, Trees and Figures

Put down lean Permanent Rose and Viridian wet-on-wet. Notice the clean grays and the magic granulations. This combination gives you nice textures for buildings, trees, figures, sky, etc.

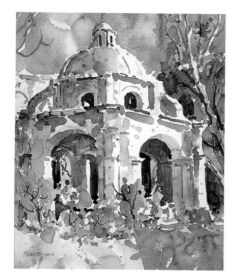

This small painting was done on location at the Ex-Convento de Santa Catalina in Oaxaca, Mexico. It's a good example of wet-on-wet mixing in the sky and foreground. I used a small amount of lean Alizarin Crimson and New Gamboge mixed with a large amount of Ultramarine Blue for the sky, and a small amount of lean Ultramarine Blue and Phthalo Green mixed with a large amount of lean Alizarin Crimson and New Gamboge for the foreground.

AT THE CONVENT
15″×11″ (38cm×28cm)

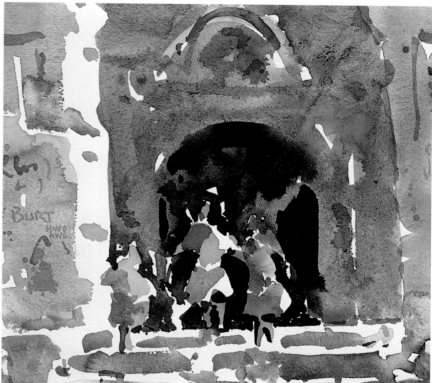

This painting detail illustrates some very nice textural effects on the building. It's mostly the result of using rich Viridian and lean Permanent Rose wet-on-wet with some Aureolin dropped into the mixture.

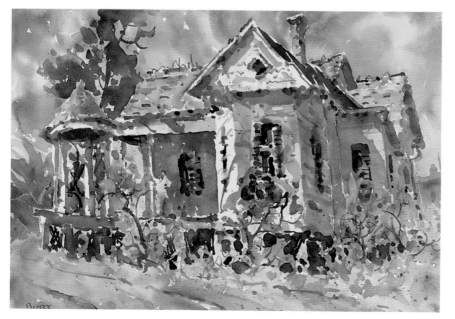

This painting is another good example of wet-on-wet middle values for sky and foreground. It was done a long time ago, before I used tray 2 for midvalues. It's a little hesitant and indecisive—which shows in the roof of the house, which is the same value as the sky. The saved whites could have been more forceful as there is not enough contrast between them (saved whites) and shadow. It shows promise.

THE WEIRD ONE
22″×30″ (56cm×76cm)

Let Them Mix:
Combinations From Tray 3

Tray 3 is both a dark and a granulating palette. I use it a lot for big, dark areas such as buildings, boats, etc. It is a versatile tray which can also be used to push out figures, trees and so forth. You can see how useful these varied darks would be in completing a painting. Put your strokes down wet-on-wet.

Tray 3 Mixing

At this point, you're probably getting the idea. Repeat the wet-on-wet mixing process with tray 3—a dark palette. These colors offer endless possibilities for transparent darks and grays. The backbone of these darks is Alizarin Crimson and Ultramarine Blue. A little spice can be added to them by dropping in a small amount of Cadmium Yellow and/or Cadmium Scarlet—just a little. Use these colors for the darks of buildings, boats, trees, figures, etc. Like you see here, make three or four samples of the Ultramarine Blue, Alizarin Crimson, New Gamboge and Winsor Yellow combinations. Give one a red dominance, one a yellow dominance and one a blue dominance. Vary the water-to-pigment ratio to get different results.

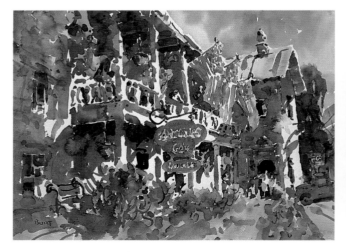

Tray 3 Darks: Example 1

This painting is an oldie, but it illustrates nicely how Ultramarine Blue and Alizarin Crimson with New Gamboge can make dramatic darks in a building. The tree symbols, however, are combinations of Phthalo Green, Alizarin Crimson and Winsor Yellow.

THE COMFORT COMMON
22″×30″ (56cm×76cm)

Tray 3 Darks: Example 2

Notice in this painting how decisive, forceful and clean the darks from both tray 3 and tray 4 are. Though this painting is a success, I can never take full credit for it or any painting. Watercolor painting is a cause-and-effect result of wet-on-wet risk taking. So though I am not solely responsible for the end product, I am always thankful for the rewards.

AN HONEST DAY'S WORK
22″×30″ (56cm×76cm)

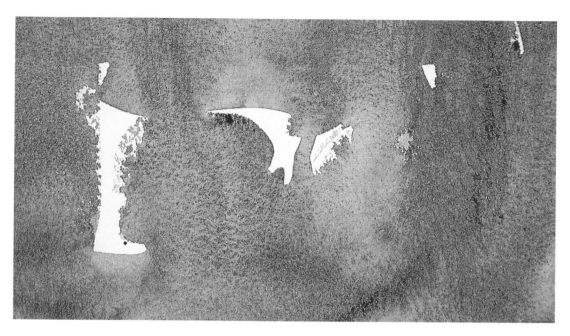

More Tray 3 Darks

You can make another very useful dark from tray 3 by putting down Ultramarine Blue and adding Alizarin Crimson to it wet-on-wet. This color can be used for the darkest darks in a rich state, or even as a dark midrange value. Use it in buildings, boats, trees, figures, hills, etc.

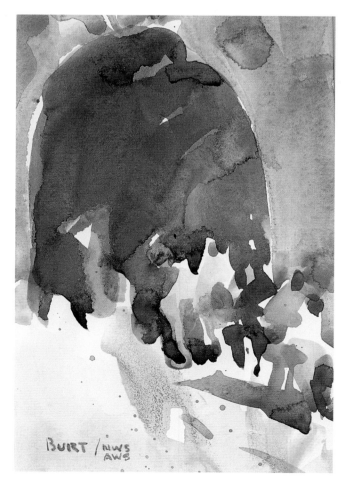

Detail of Painting

This detail illustrates the dark, transparent qualities of Ultramarine Blue and Alizarin Crimson—a dramatic backdrop for the figure symbols.

Let Them Mix: Combinations From Tray 4

Repeat the wet-on-wet process with tray 4. Make a black that has life by using a richer mixture of Phthalo Green and Alizarin Crimson. Sometimes it separates and you can see both the Alizarin Crimson and the Phthalo Green. It will granulate with a little more water. Use this for your darkest darks to push out figures and establish focal points in the final stage of a painting. Use a lean mixture to make grayed Alizarin Crimson or Phthalo Green. Drop in Winsor Yellow for variety.

The Darkest Darks

Like you see here, make four examples from tray 4 wet-on-wet. Mix rich Phthalo Green with Alizarin Crimson for a lively black. Do this again, but keep the Phthalo Green on the lean side for grayed greens or grayed Alizarin Crimson. Mix lean Phthalo Green and Alizarin Crimson with Winsor Yellow dropped in. Repeat this mixture, but vary the proportions of each color.

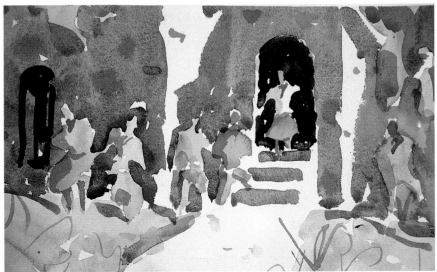

Using Tray 4

This detail of a painting illustrates the use of blacks from tray 4. They push out the orange-blue figure and make a focal point.

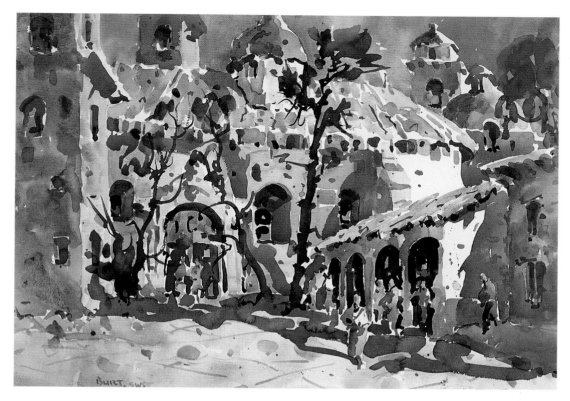

All Four Trays in Action

These two paintings show the successful use of all four trays. The first, *Mexico Pink*, was painted on location in Pátzcuaro, Michoacán, Mexico, several years ago. I had lots of help and un-asked-for advice from the locals, so I faked deafness and finished it back at the hotel. The second painting, *Calle Hidalgo*, shows just how much sparkle you can get when you don't allow pure colors to mix with their complements. I kept my grays, midvalues and darks clean and transparent by using wet-on-wet pure color mixing.

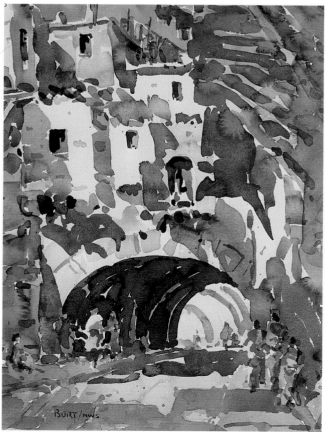

CALLE HIDALGO
17″×13″ (43cm×33cm)

Saved Whites

So far, the emphasis has been on no earth color or layering and on using pure, clean color. But another important ingredient of the successful transparent watercolor is saved white. Saved whites are areas of paper that you paint around negatively, deliberately leaving the white. These spaces, with the addition of high-chroma values, ultimately become compositional components or focal points. Many times, they are the prima donnas in the drama of the painting, with the clean colors playing a secondary, though still important, role.

Saved Whites
Saved whites are joined together to make a frame for the figures. The darkest dark (Alizarin Crimson and Phthalo Green mixture) is equal in value behind both figures, but the figure on the right is the focal point because of the saved white. I deliberately exaggerated color intensity to get the viewer's attention, and the colors in the figures were repeated in other parts of the rectangle for balance.

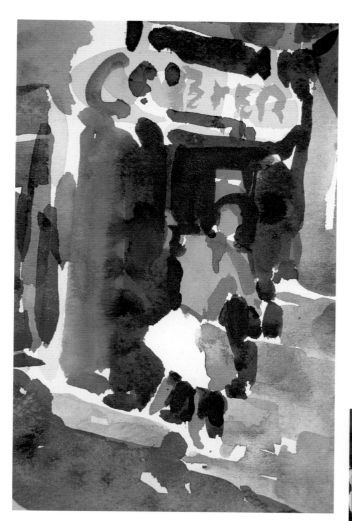

High-Chroma Colors

Saved whites and high-value (chroma) colors join to make another enclosure or tunnel around the focal point, which is the figure in complementary-colors blue and orange. It was made more important by the greenish black that surrounds it. The yellow beer sign adds interest and is echoed in the door frame to the left. The figure seems to have lost an arm, but that doesn't seem to lessen its importance.

Detail of *Dry Dock*
The visual impact and stimulation in this painting resulted from the same elements as the two previous paintings. Notice how the complementary blue and orange and saved white of the figure are pushed out by the dark.

Diamonds

Think of all the clean, intense colors as precious gems—rubies, emeralds, amethysts and sapphires—and saved whites as diamonds. They all sparkle because they are pushed out and supported by the all-important darks. Ironically, it's the small saved whites and not the large saved whites that sparkle the most. If there are large saved whites in your painting, then the small darks become more important. But if there are large darks, then the roles are reversed, and the small saved whites become important.

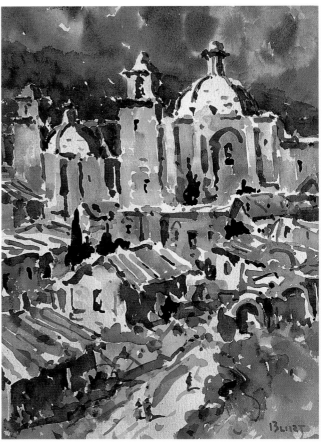

Saved High-Value Color
This painting illustrates large areas of saved whites and smaller darks against a middle value. Technically, it's made up of more saved high-value color rather than saved whites, but it's the same idea. Notice how the big church in the background appears to be the most important character.

BEYOND OAXACA
15″×11″ (38cm×28cm)

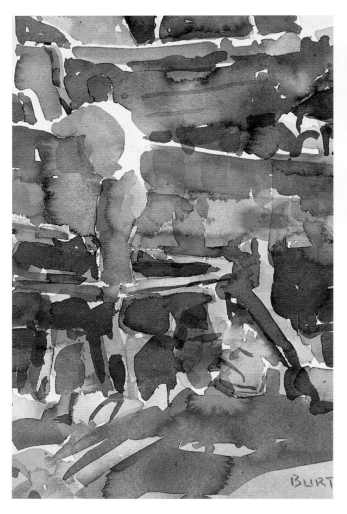

Use Darks to Push Out Saved Whites
This older work was successful with the saved white on the figure pushed out by darks from behind. The colors are more gray, but the red on the figure still vibrates because of the muted greens.

BACK TO SORRENTO
11½″×8″ (29cm×20.5cm)

No Saved White?

When you say "transparent watercolor," you should automatically think "saved white." It's the essence of watercolor and a major contributor to the sparkle category. A watercolor without any saved whites just doesn't say "watercolor." You might as well use oil, acrylic, pastel or egg tempera if you're just going to cover up all of that beautiful white sparkle. A watercolor without saved whites is like a diamond ring without the stone.

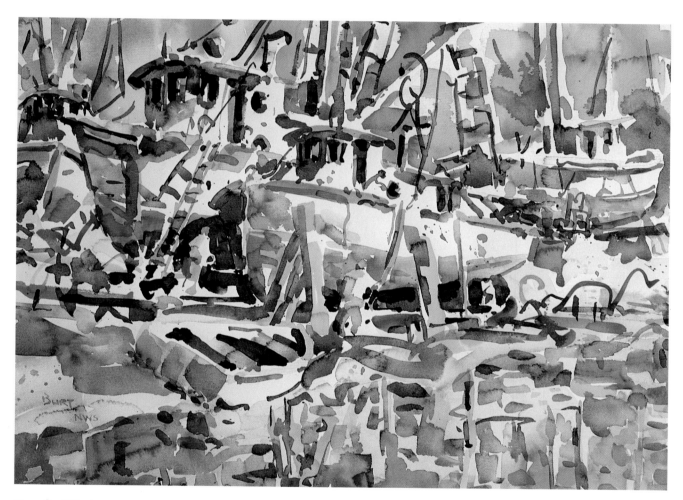

Crop for Effect

This is the best example I have of large saved whites with smaller darks against middle values. Notice how the figure to the middle left is pushed out by the darkest dark. The longer you look at this painting, the more your eyes seem to want to go to that figure. Originally, this painting measured 22"×30" (56cm×76cm), but I cropped it down to 18"×24" (45.5cm×61cm) for stronger visual impact.

TEXAS BOATSCAPE
18"×24" (45.5cm×61cm)

Masking Fluid

You could use masking fluid to preserve your white spaces in a painting, but I don't recommend it. I tried it, and it ruined all of my fun by interrupting my spontaneity. Needless to say, those pieces ended up in the trash. I think all of my creativity was used up by putting all of that rubbery stuff between the lines coloring-book style. Masking fluid is just not conducive to developing negative-painting skills, and it could easily become a nonpainterly crutch.

Negative painting is more than half the fun in transparent watercolor. I've torn up and thrown away so many sheets of Arches paper over the years because of lost whites that the company has probably shown steady growth on the French stock exchange! But these failures have not interfered with my fun. Painting is not just a means to an end. Remember that it's the enjoyment of the means, rather than the end product, that counts.

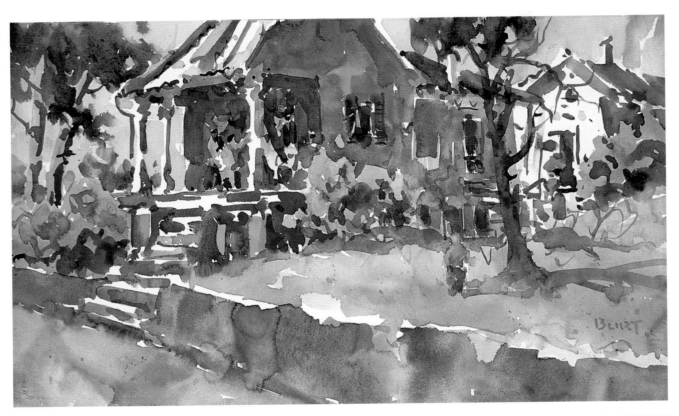

Lost Saved Whites

In Old Shanty Town is an old painting. It illustrates lost saved whites on the figures. They might not have been lost had I planned out the painting better. You can see how it would have been more effective had there been saved whites on the figures tied to other saved whites. The small figure by the tree on the right was an afterthought, and it looks it. The painting redeems itself somewhat by the clean middle values of the sky and foreground and by the dark combinations of the house and wall.

IN OLD SHANTY TOWN
14″ × 22″ (35.5cm × 56cm)

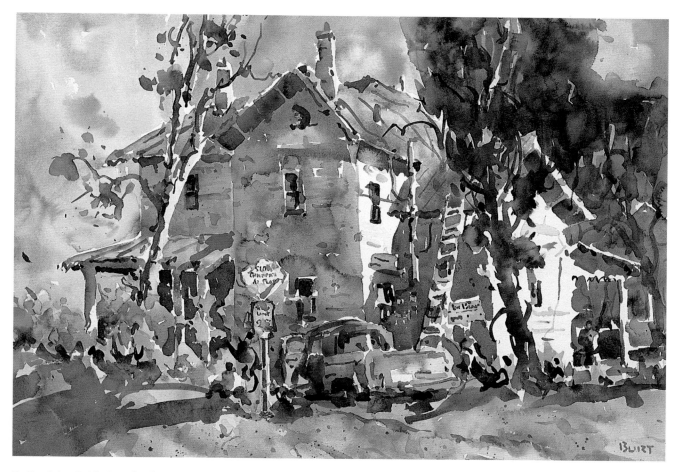

Be Decisive With Saved Whites

This painting was done a couple of years later on location in Lake Charles, Louisiana. It looks as if I had fun doing it, and it shows improvement. The color is cleaner and more vibrant than in the last painting, and the shapes are more entertaining. The smaller saved whites and larger darks against midvalues are cleaner and more decisive, though I should have saved more white on the figure under the ladder. The street sign says "Caution: Children at Play."

CAJUN RESTORATION
22″×30″ (56cm×76cm)

CHAPTER 3
Design

Good design is the process of making unequal measures in all of the individual elements of design. Like technique, design is a tool to aid the artist in his or her quest for visual self-expression. Much of design is intuitive, based on common sense. It should be learned and stored in the subconscious. Ideally, you shouldn't have to think about design all the time while you're going through the creative process. It's mandatory for most artists early on in their careers, but don't spend so much time worrying about design that you don't have time to paint. Learn it through "on-the-job training."

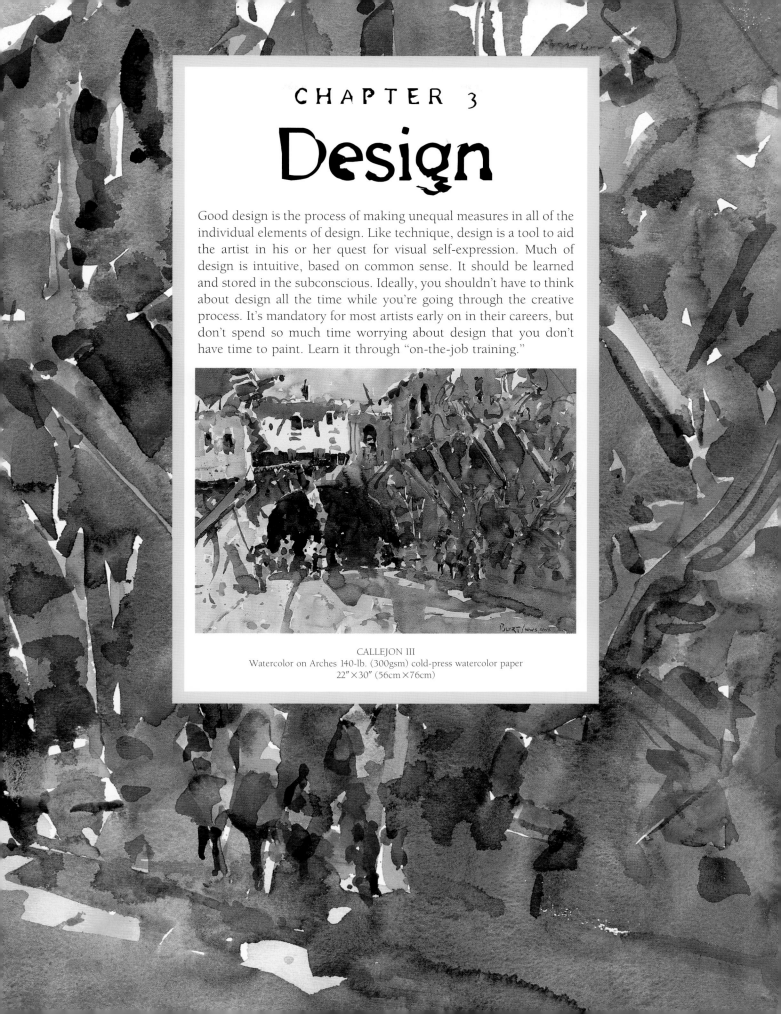

CALLEJON III
Watercolor on Arches 140-lb. (300gsm) cold-press watercolor paper
22″×30″ (56cm×76cm)

The Seven Elements of Design

Take a look at these examples of both good and bad use of the elements of design. Notice the differences, and apply these rules to your own work.

Line

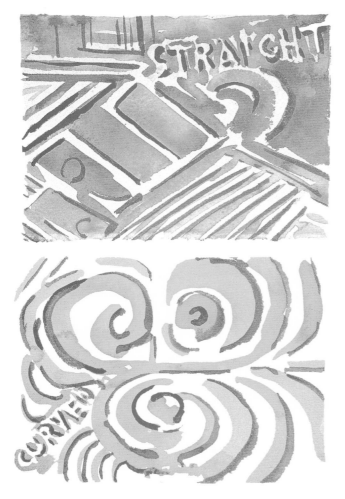

Bad
This is an example of poor use of line, where curved and straight lines are equal, with no dominance.

Good
These samples show good use of line: straight dominant on top, curved dominant on bottom. Notice the unequal measures.

> With all the possibilities of artistic leeway in alteration or rearranging, the law of unequal measures is irrevocable.
>
> —EDGAR PAYNE

Value

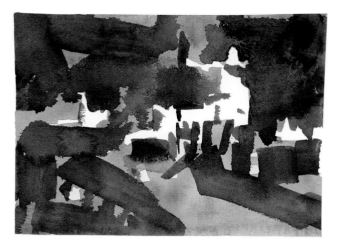

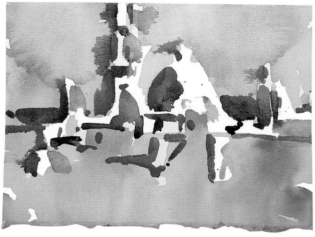

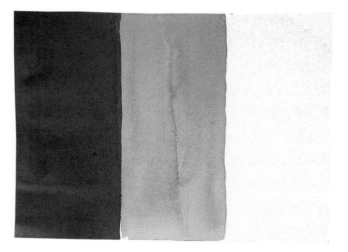

Good

Here we see good use of value. The top example shows dark as dominant, while the bottom one shows medium values as dominant. Not shown but also an option is having light values as dominant. Again, the key is unequal measures.

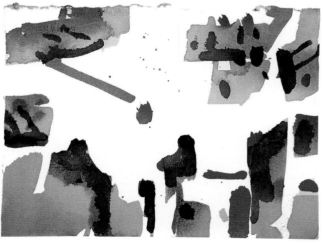

Bad

This is a bad use of value. See how dark, medium and light values are equal, with no dominance.

Color

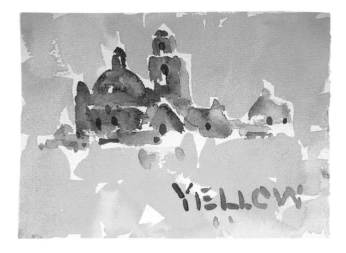

Good

A good use of color. Here we see one dominant hue. Remember that the key is unequal measures.

Bad

Where all hues are equal, we have bad use of color. No individual hue is dominant here.

Texture

Good

Good use of texture in these two examples with rough and smooth textures. See how the rough texture is dominant in the top example, while the smooth texture is dominant in the bottom example.

Bad

In this sample, there are equal measures of both rough and smooth textures, which prevents dominance.

Size

Good

In these two examples, we see good use of size. See how the small shapes are dominant in the top example, while the medium shapes are dominant in the bottom one. Not shown but also an option is having large shapes as dominant. Keep things unequal to maintain dominance!

Bad

In this sample, look how uninteresting a painting becomes when small, medium and large objects are all equal with no dominance.

Shape

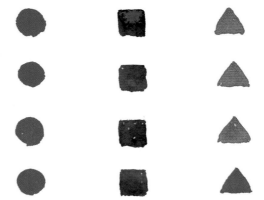

Good

This illustration shows good use of shape. Look how vibrant and energetic a painting becomes with unequal use of shapes. The top example shows round shapes as dominant, while in the bottom one, square shapes are dominant. Having triangle shapes as dominant would be another option.

Bad

This example shows poor use of shape. Round, square and triangle shapes are all used equally. No dominance can be achieved when everything is equal.

Direction

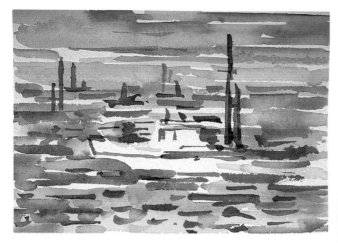

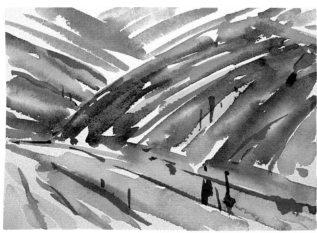

Good
Notice the good use of direction in these examples. Horizontal direction is dominant in the top sample, while oblique direction is dominant in the lower one. Vertical would be another option. Again, note how unequal measures create dominance.

Bad
Here we find horizontal, oblique and vertical direction all equal— no dominance, bad direction!

The Eight Principles of Design

Unity

• one simplified idea or aesthetic order among all of
the elements of design

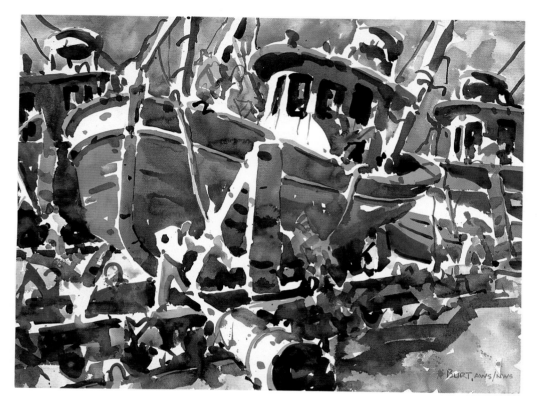

DRY DOCK
22″×30″ (56cm×76cm)

Good
This painting shows strong unity (or one simplified idea), an aesthetic order among all of the elements of design. It is important to note that this painting also has harmony, balance, conflict, dominance, alternation, gradation and repetition (we'll get to these terms shortly). The dominant pattern scheme is large dark, small light against middle values. There is also an allover pattern. Grouped mass is the dominant type of composition. There is also a strong diagonal influence.

Bad
This painting has no unity. It shows a boat on the waterfront, Central Park and midtown. None of these subjects are related or go together. The painting only has mass confusion, with no harmony, balance (informal), dominance, alternation or gradation. It has conflict, but only in a chaotic way and in value and direction only. It has repetition but is equal and unaesthetic.

Harmony

• similarities or relationships among all of the elements of design

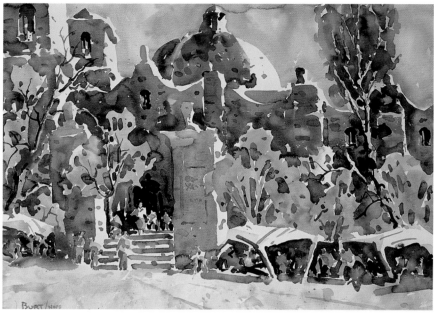

THE CATHEDRAL AT MORELIA
22" × 30" (56cm × 76cm)

Good

This painting has strong harmony—similarities or relationships among all of the elements of design. It is especially harmonious in value and color. It has unity, balance, conflict, dominance, alternation, gradation and repetition in all the elements of design. Notice how clean and transparent the pure-colored grays are.

Bad

This painting has no harmony whatsoever. It does have conflict, repetition and dominance, but only in a very boring and primitive way. The orange and yellow church is heavy and opaque. The type of balance exhibited is formal (equal) and has no place in fine art. This looks like a poster—and a bad one at that.

Balance

- informal (unequal) balance among all of the elements of design

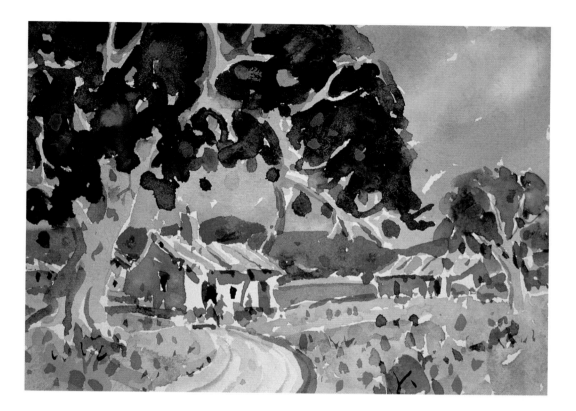

Good

This example shows informal (unequal) balance in all of the elements of design. It is particularly noticeable in size balance. The big tree on the left is informally balanced by the small tree on the right. This painting also has unity, harmony, conflict, dominance, alternation, gradation and repetition in all of the elements of design.

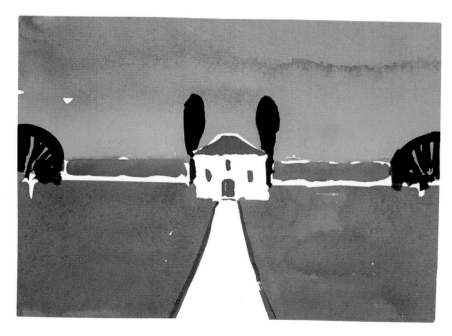

Bad

This painting has no informal balance—only equal balance. It has no unity, harmony, alternation or gradation. The conflict, dominance and repetition are symmetrical and uninteresting.

Conflict

- contrast, variety and tension among all of the elements of design

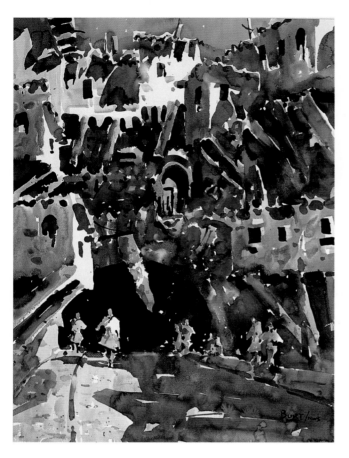

Good

This painting shows good conflict, variety and tension among all of the elements of design. The conflict is very noticeable in value. There are also big contrasts in color, shape, size and direction. There is no doubt about who the prima donna or focal point is. The dominant type of composition is tunnel. Other strong influences are radiating line, allover pattern, grouped mass and steelyard. The pattern scheme is large dark, small light against middle value. It's another good example of saved whites, saved colors and painting light to dark in stages from the four trays. The grays and darks are very clean and transparent.

CALLEJON VI
30″×22″ (76cm×56cm)

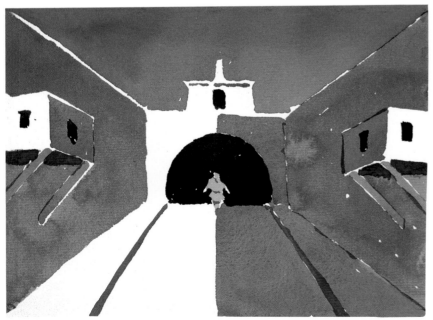

Bad

There is conflict in this painting, but it is unaesthetic, unappealing and boring. The same applies to unity, dominance and repetition. There is no alternation. The balance is equal and unacceptable. There are equal measures throughout.

Dominance

• unequal measures among all of the elements of design so that one particular design element is dominant

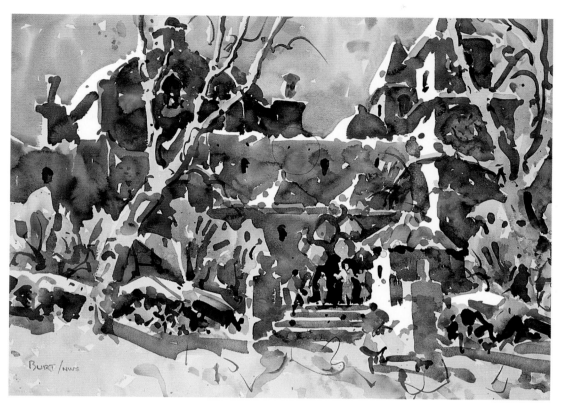

THE MEXICAN BALLOONIST
22″×30″ (56cm×76cm)

Good

This painting shows strong dominance (unequal measures) in all of the elements of design. Its dominance is most noticeable in value. The darks dominate. It also has unity, harmony, balance, conflict, alternation, gradation and repetition in all of the elements of design. Thin ribbons of saved white connect with larger saved whites and help give the painting unity. Wet-on-wet mixing of pure colors for the big dark performed their magic act very well. Even the big dark has variety in value and color.

Bad

This sample has no dominance in the elements of design because everything is symmetrical and equal. It also has no harmony, informal (unequal) balance, alternation or gradation. The conflict, unity and repetition are boring and invalid.

Alternation

- rhythms in intervals among all of the elements of design

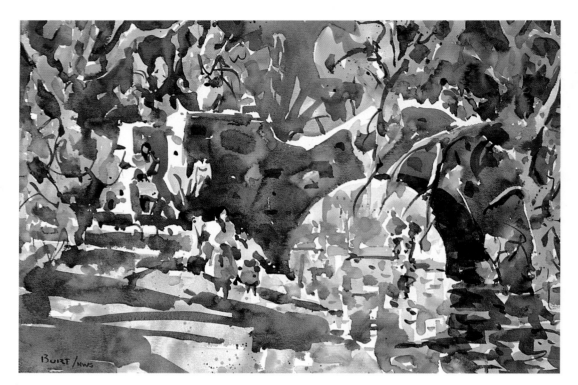

Good
This painting is another "imaginationscape." It shows strong alternation, or rhythms, in intervals among all of the elements of design. The alternation is the most noticeable in broken and opposing color, round and oblique shapes and value contrasts. It also has unity, harmony, balance, conflict, dominance, gradation and repetition in all of the elements of design.

ON THE RIVERWALK
22″×30″ (56cm×76cm)

Bad
This painting has no alternation in any of the elements of design. Nothing is convincing, and once again there are equal measures throughout. There is a color dominance, but that's not enough to redeem the painting.

Gradation

- gradual changes in any direction—vertical, horizontal, oblique—in all of the elements of design

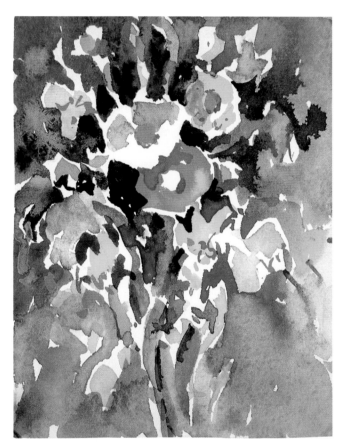

Good

This small floral shows gradation, or gradual change, in any direction (vertical, horizontal, oblique) in all of the elements of design. There is a gradual change in line, value, color, texture, size, shape and direction whether you go from top to bottom, left to right or corner to corner. The focal point of this painting is made up of the orange and the white and blue flowers that are surrounded by the darkest darks.

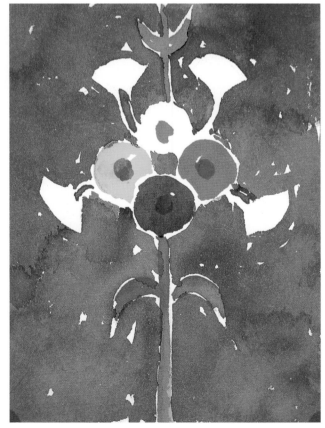

Bad

This bad example has no gradation, unity, harmony, balance, conflict, dominance or alternation. There is repetition, but it is equal and unaesthetic. It has the same affliction as all of the other bad examples—equal measures!

Repetition

- duplication among all of the elements of design, with one particular element dominant

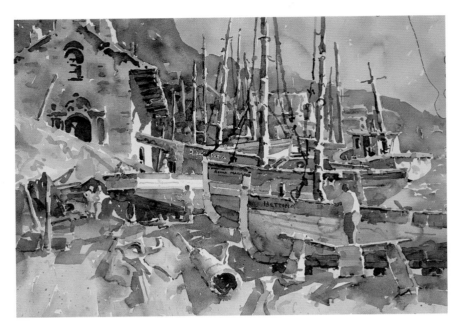

ITALIAN BOATSCAPE
22″×30″ (56cm×76cm)

Good

This painting, which won the Alice Melrose Memorial Award at the 48th Annual Audubon Artists Exhibition in New York, and an award of excellence at the 15th Annual Western Federation of Watercolor Societies Exhibition in San Diego, is a strong example of repetition of all the elements of design. It was done in the studio, but the original concept was born on location in Sorrento, Italy. There is repetition throughout line, value, color, texture, size, shape and direction, but none of the repeats are identical. It also has unity, harmony, balance, conflict, dominance and alternation in all the elements of design.

Bad

This bad example has none of the good qualities of the previous painting. The repetition is equal and uninteresting. All of the other principles are lacking because of equal measures.

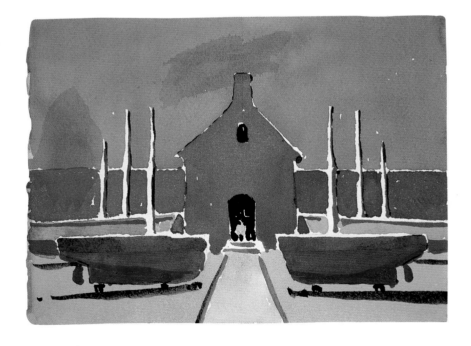

Pattern Schemes

Pattern schemes create readability, lucidity of statement and breadth of effect in a painting. The six broad pattern schemes are

- a piece of darker value in a lighter area (as in a silhouette)
- a piece of lighter value in a darker area
- a small light value and a large dark value against middle values (used in many of my paintings)
- a small dark value and a large light value against a middle value
- gradation in any direction—horizontal, oblique or vertical
- allover pattern (usually an abstract pattern that has informal balance throughout the entire painting)

Lighter Value in a Darker Area
Taken from an on-location painting done on the Riverwalk in San Antonio, Texas, this detail illustrates light on dark.

Darker Value in a Lighter Area
This is the best part of a 15″×22″ (38cm×56cm) on-location painting of a train station in a small town in southern Spain. Though the rest of the painting was not redeemable, this detail illustrates nicely a piece of darker value in a light area. The figure symbol is not that dark, but it seems dark against the saved white of the building behind it. It also demonstrates texture and granulation.

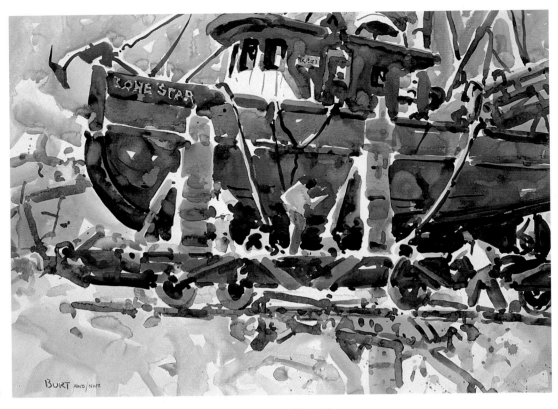

ROCKPORT REPAIRS
22″×30″ (56cm×76cm)

Small Light Value in a Large Dark Value Against Middle Values
Many paintings reproduced in this book utilize this pattern scheme. I like it because it makes the small saved whites sparkle like diamonds. It also makes the saved high-chroma color and high-value color important.

Small Dark Value in a Large Light Value Against a Middle Value
Though this is an oil painting, it nicely illustrates small darks and large lights against a midvalue. I seldom use this pattern scheme because the saved whites lose their importance when they cover the largest area.

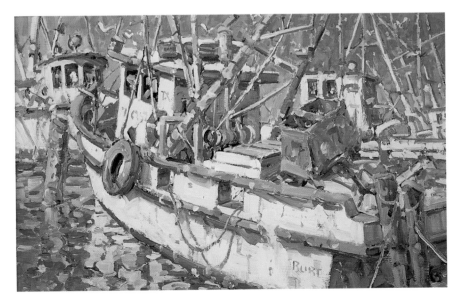

THE FULTON MARINA
Oil on canvas
20″×30″ (51cm×76cm)

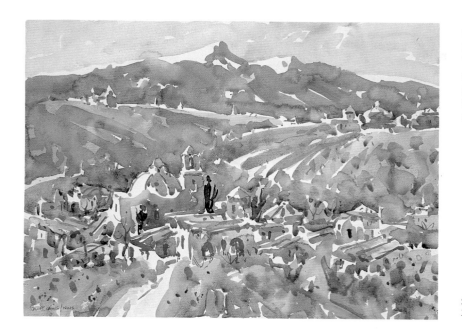

**Gradation in Any Direction—
Horizontal, Oblique or Vertical**
This painting illustrates gradation obliquely
as it goes back into space. The diagonals
give it a lot of rhythm. It shows gradation
in line, value, color, texture, size, shape and
direction.

SPANISH DREAMSCAPE
22″×30″ (56cm×76cm)

Allover Pattern
This example, a successful detail from a painting that didn't work
out, demonstrates the allover pattern scheme. It is indicated by
visual strength throughout the entire painting. This scheme has
unequal, informal balance and usually has an abstract pattern.

Types of Composition

Closely related to pattern schemes, and overlapping with both elements and principles of design, types of composition should be used as means to an end rather than as ends in and of themselves. They shouldn't be isolated and used as recipes because they would make your motives too obvious.

It is natural and intuitive for all painters to use and combine more than one of these types of composition. Of course, one type will be dominant over other types in any one painting. For example, if a painting were dominant in the radiating line type, there might be echoes of the steelyard or triangular. The possibilities for combinations and originality are endless and enhance fun and creativity.

Radiating Line

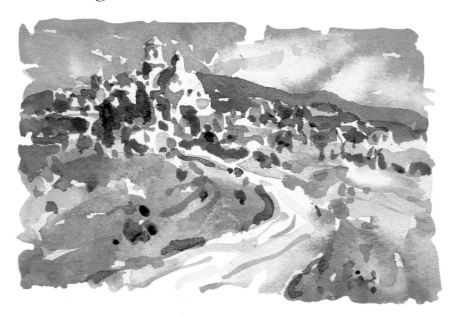

Radiating Line
The dominant type of composition in this example is radiating line. Even the cloud symbols lead to the church.

Cross

Cross
The cross type dominates this painting. The pattern scheme of the boat is large light and small dark against mostly midrange values.

> Someone once said, "Art is the art of disguising the means that created it."
>
> —EDGAR PAYNE

Three Spot

Three Spot
The three spot is a very obvious type of composition. The distance recedes in color, making a nice gradation pattern scheme.

Triangular

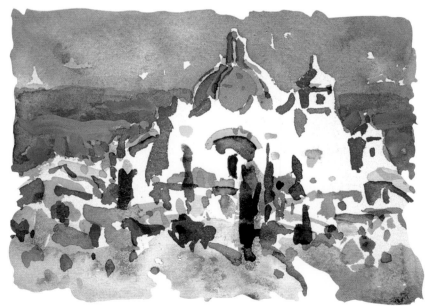

Triangular
Triangular is the most obvious type of composition, as shown in this painting. The pattern scheme is a large light, small dark against a midvalue.

Diagonal

Diagonal
The diagonal type is also rather obvious. The rapid downward flow of the main diagonal is stopped by the intersecting diagonal background hill on the left and by the intersecting diagonal foreground traveling in the opposite direction. The pattern scheme is large dark, small light against midvalues.

Silhouette

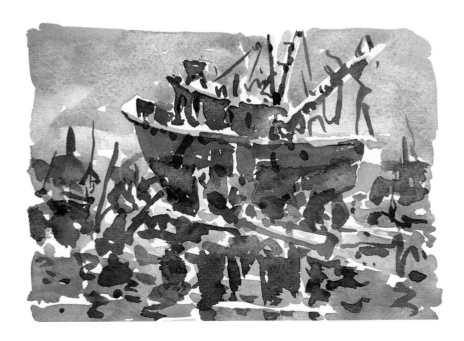

Silhouette
Here we see an example of the silhouette pattern scheme. The subject of this painting almost forms a traditional, classic silhouette, but the small lights and saved whites prevent it from being so.

Steelyard

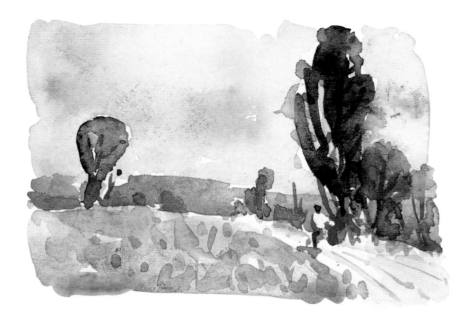

Steelyard

The steelyard is defined by a large weight (or object) near the fulcrum (or balance point) of the painting, which is then balanced by a small weight (or object) far away from the balance point. The focal point of your painting should be placed on or near this balance point if you choose to use this type of composition. For this particular painting, the focal point is the figure strolling down the road.

L or Reversed L

L or Reversed L

The L type of composition is similar to the steelyard. Here it is formed by the strong vertical tree symbol meeting the darkest line of hills in the background, forming an L shape through the painting.

S or Reversed S

S or Reversed S
The strongest influence in this painting is
the S formed by the tree and the road.

Grouped Mass

Grouped Mass
This type of composition is formed by a ver-
itable bouquet of objects. See in this paint-
ing how it is illustrated by all of the objects
that overlap and touch. Most floral and still-
life paintings use this type of composition.

HER FAVORITE THINGS
25″×41″ (63.5cm×104cm)

Tunnel

Tunnel
This detail from a 22″×30″ (56cm×76cm) painting illustrates the tunnel composition type. There is one main tunnel with two lesser ones. The main character has been pushed out with the Phthalo Green/Alizarin Crimson mixture from tray 4.

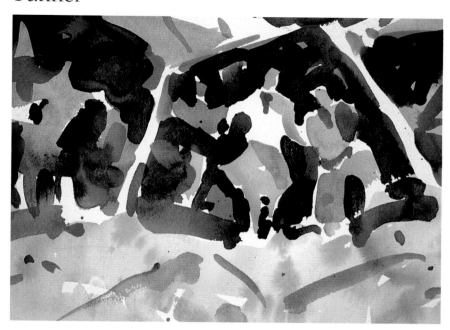

Circular

Circular
This detail from another 22″×30″ (56cm×76cm) painting illustrates the circular type of composition. The contour of the tree symbol is very round.

Allover Pattern

Allover Pattern
This successful detail from an unsuccessful painting symbolizes the superstructure of the retired aircraft carrier *Lexington*. It illustrates well an allover abstract pattern.

> Originality in art is not a matter of trying to invent new principles, but is a matter of creating new modes or mannerisms based on artistic fundamentals.
>
> — EDGAR PAYNE

Learn As You Go

Familiarize yourself with design, pattern schemes and types of composition, but don't be a slave to them. Go on with the fun of painting, and learn design as you go. The key words are *persistence* and *enthusiasm*. There are people with lots of talent but little determination or enthusiasm. They don't go far. There are people, however, with only a little talent who are filled with the art spirit. They are enthused with the challenge and practice like concert pianists or violinists. They recover quickly from failures. They jump into the water with reckless abandon and enjoy taking risks. They enjoy the journey, even with its pitfalls. Eventually, they are the ones who become true artists.

Practice Makes Perfect

There's an old adage that tells of a tourist in New York City. He stops to ask a passerby on the street, "How do you get to Carnegie Hall?" to which the New Yorker promptly replies, "Practice." Practice is the fabric of any artist, whether a pianist, a dancer or a painter. The trick to practice is to find your optimum—not too much, not too little. Everyone has a difference tolerance. Don't work yourself to death so that painting is no longer fun. When exhausted, stop and rest. When rested, paint. Though trite, the old cliché "practice makes perfect" still rings true.

This painting is another "imaginations-cape," so I took liberties with both perspective and subject. The design and my own feelings about the subject were important to me. I wasn't thrilled by my first attempt, so what you see here is a second try on the other side of the paper. It was done using the four trays with which you should be well acquainted by now, although I was forced to deviate slightly since I was out of Ultramarine Blue at the time. I substituted Phthalo Blue, which is a darker, more transparent color. Mixed with New Gamboge and Alizarin Crimson, it made nice darks and grays. A little Hansa Yellow, Cadmium Yellow and Cadmium Scarlet were dropped into it for variety.

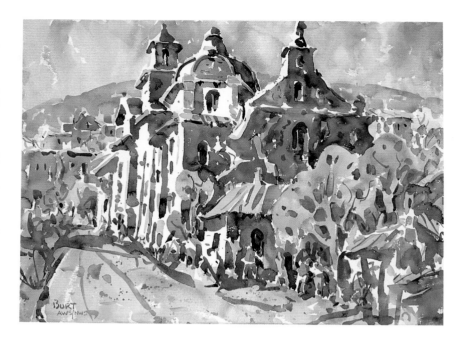

THE CATHEDRAL AT ASSISI
22″×30″ (56cm×76cm)

> It is well to keep in mind that realism must always yield to artistic unity and that artistic license is always at hand.
>
> —EDGAR PAYNE

Never Be a Slave!

Now that you have an understanding of the elements and principles of design and of the roles of pattern schemes and types of composition, you can get on with the fun of painting. Remember to never be a slave to the tyranny of rules. Learn them and let go!

> Failure is a stimulus. The way of painting is the way of trial and error. Each of us starts from zero and cannot resume where another left off. Each false start, each utter failure, is part of the fabric of an art career. If you do not have the grit to confront your own ignorance and if you are not willing to ruin acres of paper, you are in the wrong field.
>
> —FRANK WEBB

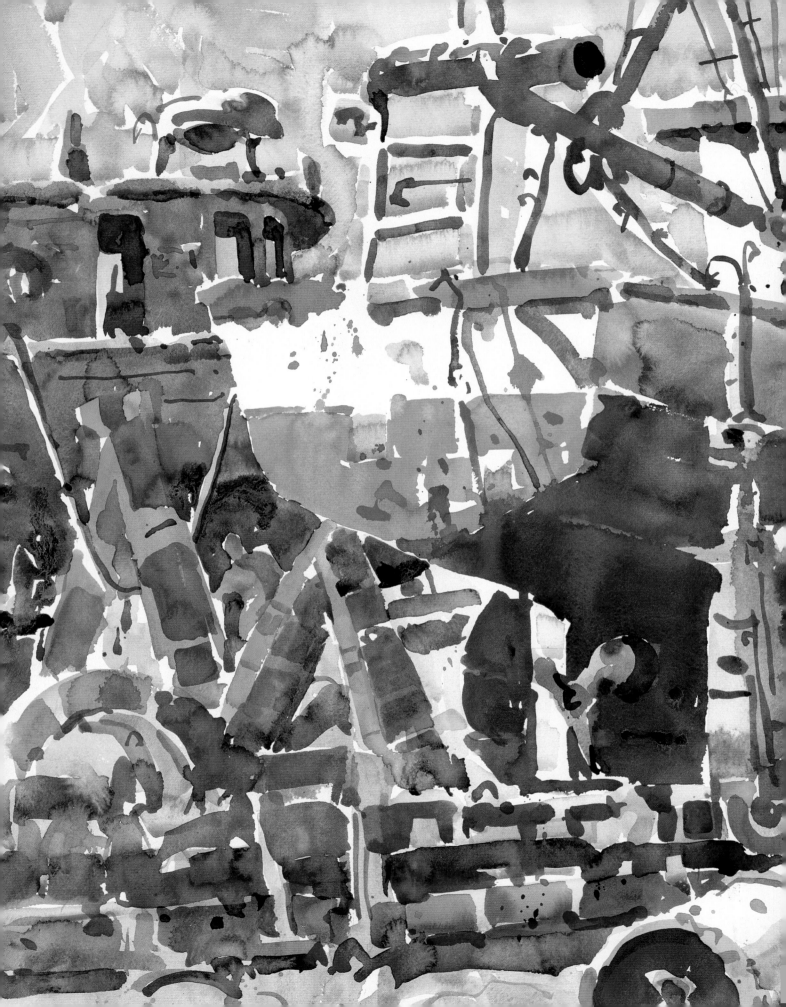

CHAPTER 4
Putting It All Together —

DEMONSTRATIONS

Enough time has been spent talking about materials, technique and design. Now is the time to loosen up, have fun and do something, even if it's wrong. If you do it wrong—and we all do it wrong at times—then do it decisively. Nothing is more obvious to the viewer than indecision—overworking or reworking a painting.

As you work, you'll go from light to dark in four stages, painting around saved color and saved whites and working on dry paper. Use a big round or even a big flat brush whenever possible. Lay out your pigments and puddles just as I showed you in chapter two, and make your colors as intense as possible, as they will dry lighter than they appear while wet. Do not pre-wet your paper, and do let each step dry before proceeding to the next. Don't worry if your painting doesn't look right in the beginning. If it looks wrong in a concrete way, it could be right in an abstract way. Give it a chance. Remember, art is an abstract subject in which two plus two does not always equal four. Don't blot accidents right away, either. Watch the paper—they could be magic accidents!

BIG SISTER
25″×41″ (63.5cm×104cm)

Texas Boatscape

Go through this demonstration step-by-step just like you did the painting-technique exercises. There is really no difference between the two, except here you are making more definite shapes.

Though this painting is not perfect, it's got punch. The rigging could be a bit darker, and the main character seems to have lost an arm during the painting process. However, the whole thing didn't take but 1½ hours, and it was fun! This painting is not intended as a recording of facts. It is, as are all of these paintings, an "imaginationscape."

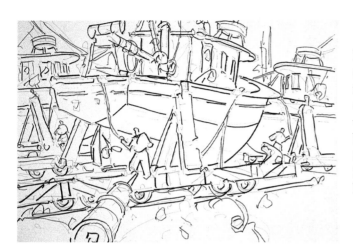

1 Sketch Light and Loose

Using a 6B pencil with a well-rounded tip, make a light preliminary sketch to indicate initial placement, directions and size of the subject. Indicate locations for important symbols such as figures, flowers, trees, windows or doorways, and most importantly, saved whites. The sketches you see here are all done with black ink on a separate sheet of Arches 140-lb. (300gsm) hot-press paper so that they stand out better for illustration's sake. Your sketch should never be this heavy.

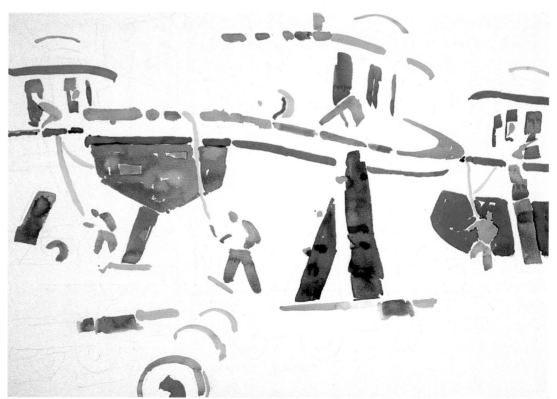

2 High Chroma Color With Opposites

Put in Cobalt Blue from tray 2, and let it dry. Put in Phthalo Green from tray 4, and let it dry except for the green vertical buttress that supports the main boat, into which you'll drop some Alizarin Crimson and Winsor Yellow while it is wet. Next put in Cadmium Scarlet and a little Cadmium Yellow from tray 1, and let dry.

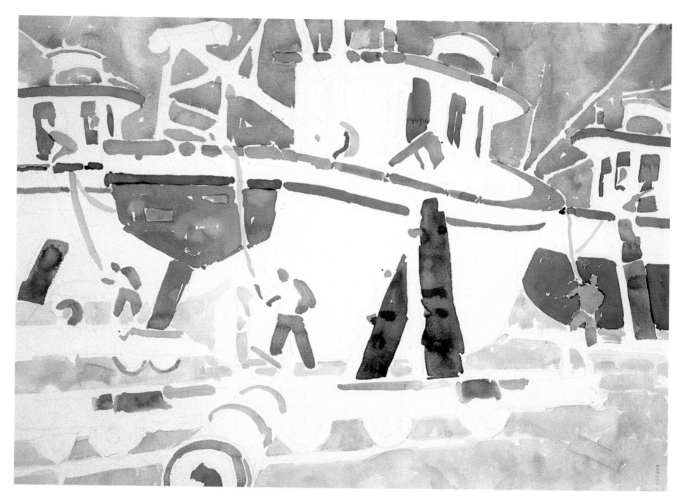

3 Middle Values

Paint in the sky middle values wet-on-wet from tray 2. Put down a few strokes of Aureolin and Permanent Rose, and then add larger areas of Cobalt Blue and let it blend wet-on-wet. Paint negatively around all of the boat shapes, especially your saved whites. Make the sky dark enough to push out the saved whites of the boats.

Next paint your foreground middle values (paint them lighter than the sky, as it makes the darks of the boats more emphatic). First put down a few strokes of Cobalt Blue, and then lay in larger areas of Aureolin and a little Permanent Rose, letting it blend freely just as you did for the sky.

A suggestive or sketchy drawing is the best base for breadth in painting. This aids materially in developing the facility to grasp the large aspects and translate them broadly. It also helps to get away from the habit formed by many students of drawing a rigid outline around each object, then filling in these boundaries with color—an inartistic habit, easily enough formed but difficult to get rid of.

— EDGAR PAYNE

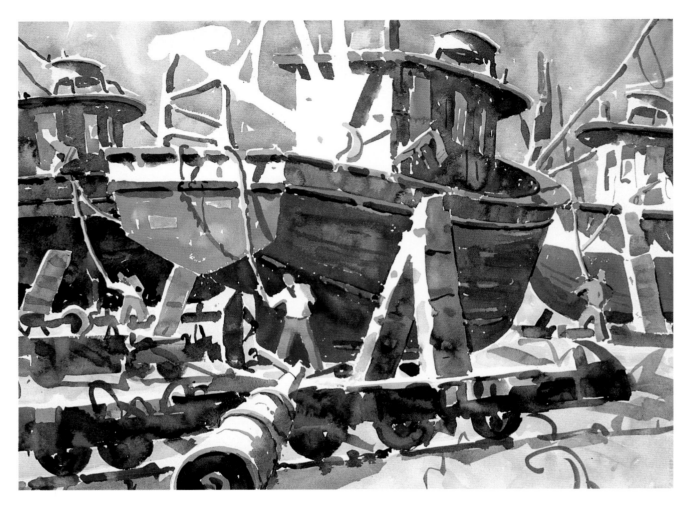

4 Dark Values

From tray 3, paint the darks of the background boat wet-on-wet. Use mostly Ultramarine Blue, and drop in a little New Gamboge. Before it dries, drop in a speck of Cadmium Scarlet and/or Cadmium Yellow. Paint negatively around the back end of the main boat. Once dry, put in the dark green (from tray 4) using Phthalo Green with a touch of Alizarin Crimson. Drop a speck of Cadmium Scarlet and/or Winsor Yellow into it before it completely dries. Now go to the background boat on the right, repeat these steps and let dry.

For the main boat, use the same wet-on-wet process, starting at the top. Use mostly Ultramarine Blue with a little New Gamboge. Drop in little bits of the Cadmiums and Winsor Yellow. Next, paint in the dark red (mostly Alizarin Crimson with a little Ultramarine Blue), and drop in some Winsor Yellow with a little Phthalo Green before it dries.

Once everything has dried, paint in all of the dark substructure underneath the boats using mostly colors from tray 4. Drop little bits of Cadmiums into this wet mixture. Paint around the round object (a saved white) in the foreground. Put some lighter Ultramarine Blue shadows in the immediate foreground, and let all this dry.

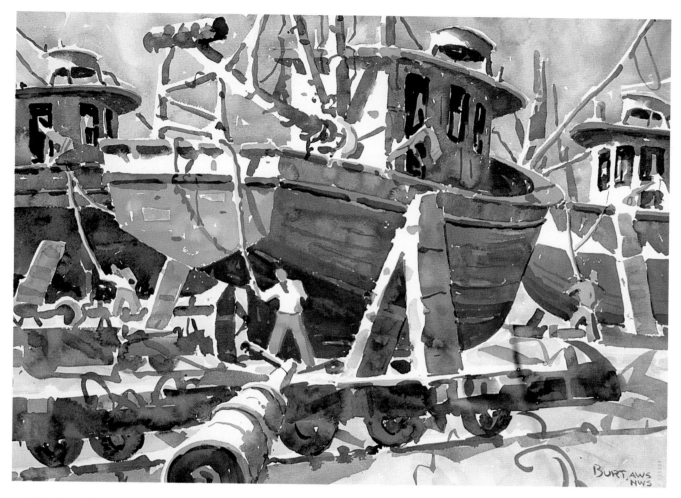

5 Darkest Darks

Start at the top with the rigging, and use Ultramarine Blue and Alizarin Crimson from tray 3. Save some whites on the rigging. Put in the windows and doorways using Phthalo Green and Alizarin Crimson from tray 4 (make the main boat's windows and doors the darkest). Use Ultramarine Blue and Alizarin Crimson on the bottom of the boat around the figure, or Phthalo Green if Ultramarine Blue is not dark enough. Zingo, you're done!

TEXAS BOATSCAPE
22″×30″ (56cm×76cm)

Mexico Tipico

In this demonstration, you'll work just as you did in the previous one, but with one exception which I will point out in step 2. In general, work from light to dark, and paint negatively around saved colors and saved whites.

Preliminary Sketch

Just as in the previous demonstration, sketch out all essential lines and directions. It doesn't have to be perfect. Draw approximate shapes that indicate size and placement of color and where to put the saved whites. Try to keep unequal measures in line, size, shape and direction.

2 High-Chroma Color With Opposites

Put in all of the intense colors with their opposites, but do not allow it to mix. Generally, work from light to dark, with the exception being the dark middle value shape going horizontally across the lower part of the paper. Place it first so that you firmly establish the color and shapes of the figure symbols. Let the figures dry before painting around them with a wet-on-wet dark.

Now without mixing, put in Cobalt Blue and let dry. Put in Scarlet Lake (or Cadmium Scarlet) with a touch of Cadmium Yellow and let dry. Put in Scarlet Lake (or Cadmium Scarlet) with a touch of Opera, and then put in Phthalo Green from tray 4, and let dry. Put in Permanent Rose, Aureolin, Viridian and Cobalt Blue, and let dry. Do not allow the figures to mix during this process.

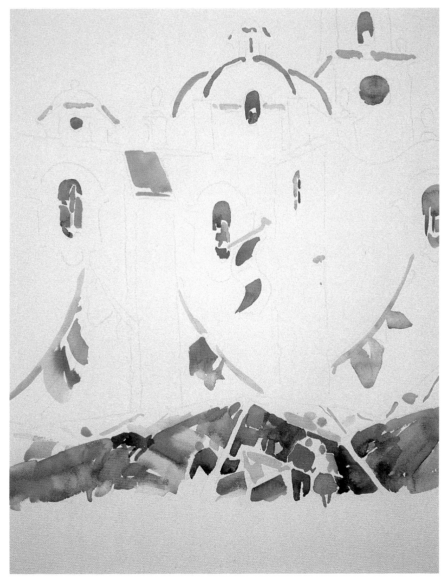

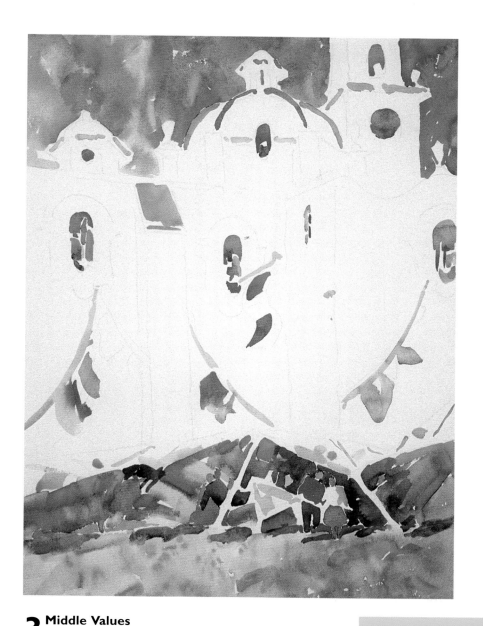

3 Middle Values

Put in the important middle values for the sky and foreground wet-on-wet. These values determine how dark the darks should be. For the sky, use tray 2. Put in a few small strokes of Aureolin and Permanent Rose, put down large strokes of Cobalt Blue, and let it mix on the paper for a predominant cool. For the foreground, put in a few small strokes of Cobalt Blue, large amounts of Aureolin and a little lean Permanent Rose. Let it all mix on the paper for a predominant warm. If the color is too warm, drop in some Cobalt Blue and/or Viridian before it dries.

Visualize, don't copy. Creativity requires us to make our own shapes, values and color. Color comes from you and your palette, not from the subject. Try to formulate a special color strategy for each painting. It is better to be wrong than indecisive.

— F R A N K W E B B

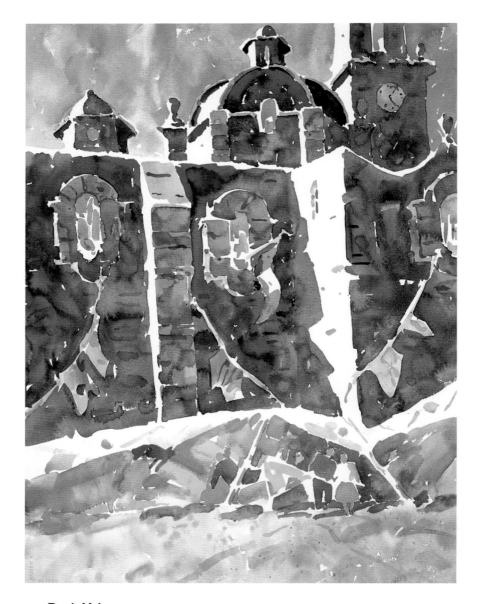

4 Dark Values

From trays 3 and 4, put down all of the large darks, starting with Phthalo Green and small amount of Alizarin Crimson. Drop in a little Winsor Yellow while it's wet. Put in the darks of the buttress wet-on-wet using Ultramarine Blue, Alizarin Crimson and a little New Gamboge, and let dry. Add other darks by using Ultramarine Blue, Alizarin Crimson, New Gamboge, Phthalo Green and Winsor Yellow wet-on-wet. Drop in very small amounts of Cadmium Yellow and Cadmium Scarlet, but beware of dropping in too many Cadmiums, as they will look heavy and opaque when dry. Allow these darks to mix on the paper. Paint around the flag, saved whites and other colorful midvalue shapes.

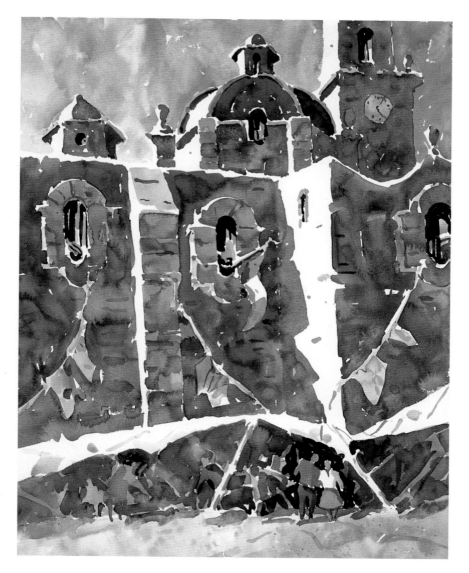

5 Darkest Dark Values

The darkest darks of this painting accent the windows, push out the figures under the awning and accent the main character (the figure with the saved white blouse, orange skirt and blue shadow). To achieve this effect, put down your darkest darks using Ultramarine Blue and Alizarin Crimson from tray 3. Use Phthalo Green and Alizarin Crimson from tray 4 for the darkest dark behind the focal point figure (make the mixture rich if you want it really black). Make sure it is darker than the others, as it frames the focal point.

MEXICO TIPICO
30″×22″
(76cm×56cm)

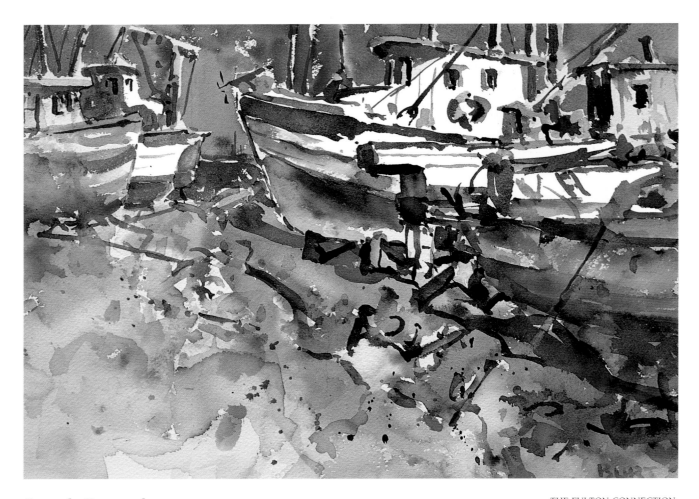

Expect the Unexpected

This painting was done under dire conditions, yet it turned out good. I was painting on location, standing in a boat repair yard on the gulf coast in Fulton, Texas. I was leaning into gale force winds. Some of my puddles were beginning to run together, and my easel and palettes were on the verge of blowing away. I was smoking a pipe at that time, and some of the embers were blowing into the palettes, which were literally smoldering. I made a quick three-minute sketch, and bingo, the whole thing was done twenty minutes later. The heavy wind instantly blew each of the four stages dry. The wind blew the mosquitoes away, too!

THE FULTON CONNECTION
11″×15″ (28cm×38cm)

Umbrian Light

The concept for this painting came as a result of a recent workshop that I conducted in the Umbrian hill towns of central Italy. This is a piazza in Stroncone, a medieval town that clings to the side of a mountain—a miracle considering the fact that the area experienced four minor earthquakes during the two weeks that I was there! The villagers were warm, friendly and happy, and some schoolchildren came out and asked for all of our autographs. Apparently someone in our group told them that we were famous American artists. It's nice to be appreciated!

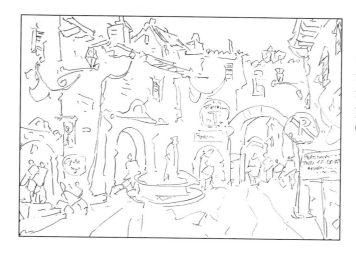

Preliminary Sketch

Sketch out your painting light and loose with a 6B pencil. Remember that your drawing is only an approximate road map. You can always take detours as needed in the interest of design. Don't be a slave to correct perspective. Realism must always be sacrificed to good design.

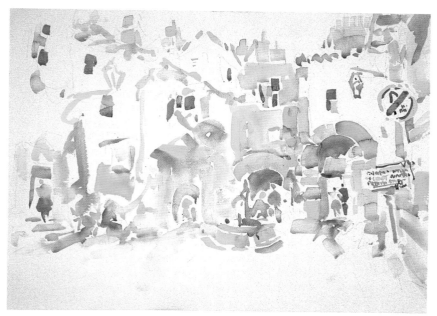

2 High-Chroma Color With Opposites

Paint in the focal point figures and spotted-in high-value color throughout the building area using trays 1 and 2 and Phthalo Green from tray 4. Allow very little wet-on-wet mixing here, especially with the figures under the arch, signs, and so forth, around the focal point. As far as the other high-value colors are concerned, you can allow some mixing. It's easy to see where that happened. Wherever the paints are allowed to mix, you'll see grayed color, soft edges and less-distinguishable forms.

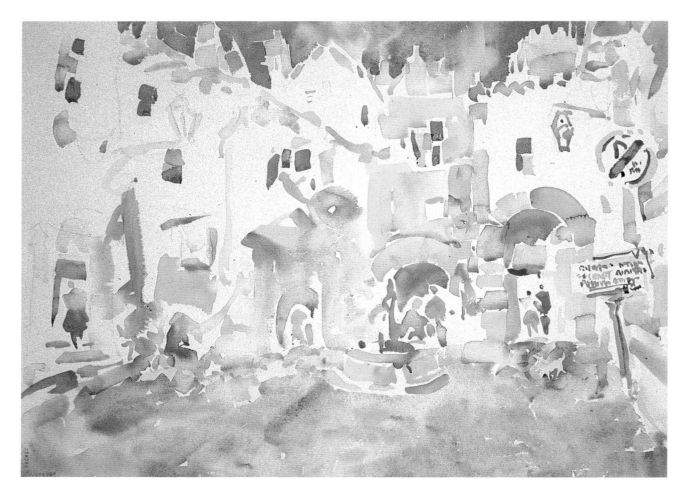

3 Middle Values

Using tray 2, paint negatively around the shapes of buildings. For the sky, put in some small strokes of Aureolin and Permanent Rose, with large strokes of Cobalt Blue. Let it mix wet-on-wet, and then let dry. For the foreground, put in small strokes of Cobalt Blue with large strokes of Aureolin and Permanent Rose for wet-on-wet mixing. Again, paint negatively around building shapes, and let dry.

Do not paint things; paint conditions, impressions, ideas or senses. Do not paint what is; paint what could be, and even more importantly, what ought to be.

— FRANK WEBB

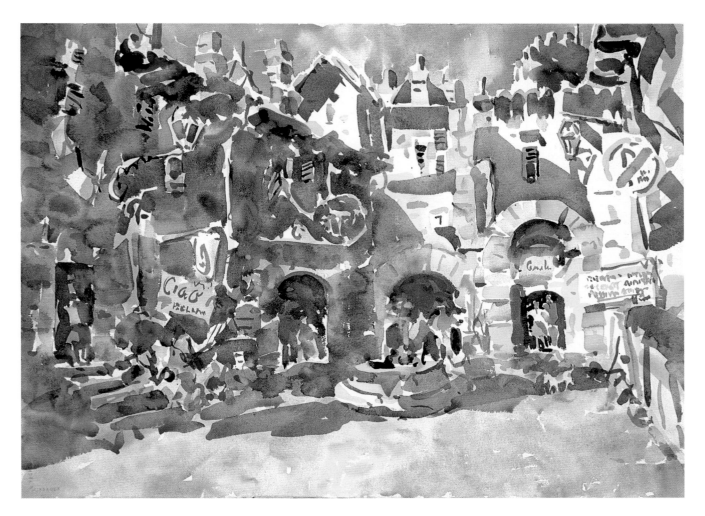

4 **Dark Values**
Put in all of the darks wet-on-wet from trays 3 and 4. Starting on the left buildings and moving to the right, put down Ultramarine Blue and Alizarin Crimson. Then put in some Phthalo Green and Winsor Yellow. Use Ultramarine Blue and a little New Gamboge for shadows and cast shadows on the left and right. Notice how the shadow on the lower right has pushed out a symbol for a dog. Use Phthalo Green and Alizarin Crimson alternated with Ultramarine Blue and Alizarin Crimson in places like eaves, windows and doorways. Drop very small amounts of Cadmium Scarlet and Cadmium Yellow into these dark wet mixtures, and let everything dry.

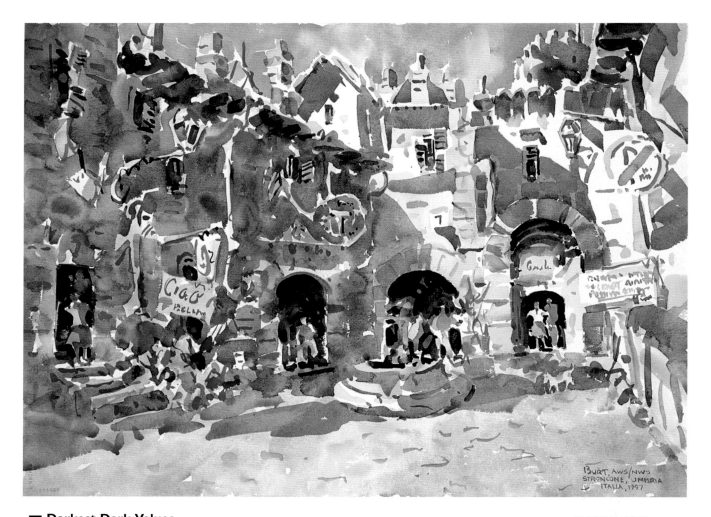

5 Darkest Dark Values

Use Alizarin Crimson and Phthalo Green for the darkest darks in doorways, windows, eaves, wells, etc. Paint the dark accents for the steps, signs and so forth, with a mixture of Alizarin Crimson and Ultramarine Blue. Drop very small amounts of Cadmium Scarlet and Cadmium Yellow into these darks while wet, and remember to paint negatively around saved whites and other saved color—especially the focal point under the double archway at the right. Put the darkest dark around those figures.

UMBRIAN LIGHT
22″×30″ (56cm×76cm)

Always Persevere

This painting was done on location in Fredericksburg, Texas, on a chilly but sunny fall day. I was standing on a flat surface, so my puddles worked well. I worked fast because I was cold. The wind speeded up the drying, so I didn't have to wait long to go to the next stage. Some people came over to watch, but they didn't stay to give me a critique because of the cold. Also, people usually won't stay long when the painting is in a disconnected, chaotic stage. They want to see results, and they want to see them now.

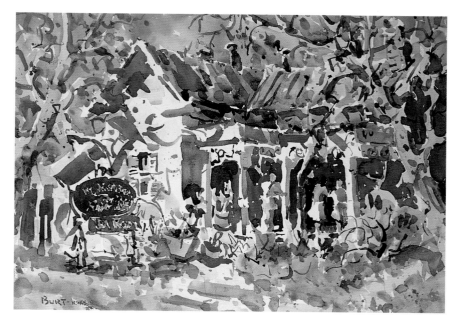

THE GOSSIP CENTER
22″×30″ (56cm×76cm)

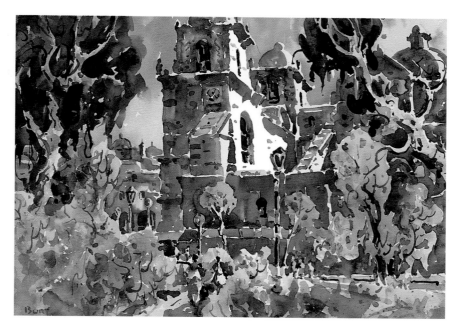

OAXACA TIPICA
22″×30″ (56cm×76cm)

Let Go and Have Fun

This was another painting done on location seemingly against all odds. As I was working, an instant crowd gathered around so close that I could barely lift my arms. I was harassed and bombarded with chatter and questions. Once again I faked deafness, hoping the crowd would get bored and leave. I did my six- or seven-minute sketch as usual, but suddenly I then lost all of my inhibitions and plunged into the painting with reckless abandon. The elevation, warm, sunny weather and low humidity all contributed to each step drying quickly. The crowd thinned out because the painting looked chaotic and they didn't want to invest any more of their time in it. The key here was that I gave up caring whether the painting succeeded or not. I just wanted to have fun.

The Mexican Balloonists

The concept for this painting came from looking at the cathedral on the main plaza of Oaxaca, Mexico. The original painting was *Oaxaca Tipica* (on the previous page), and you can see that this demo has been radically redesigned from that original painting in color, shape, size and direction.

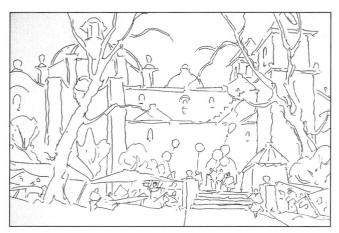

Preliminary Sketch

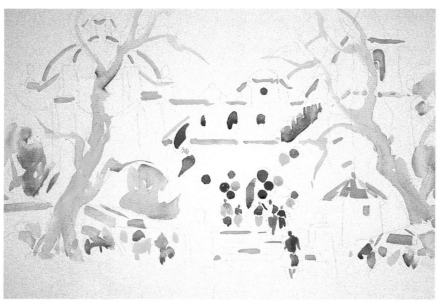

2 High-Chroma Color With Opposites

Put down high-chroma color with opposites, using trays 1 and 2 and Phthalo Green from tray 4. Use these colors for figures, balloons, trees and the broken outline of the church. Paint the flag using Phthalo Green and Cadmium Scarlet mixed with a touch of Opera. Put in some less intense color for figures under the awnings. Put in Cobalt Blue for window symbols and for part of the awnings. Also, use combinations of Permanent Rose, Viridian and Aureolin wet-on-wet for the tree symbols.

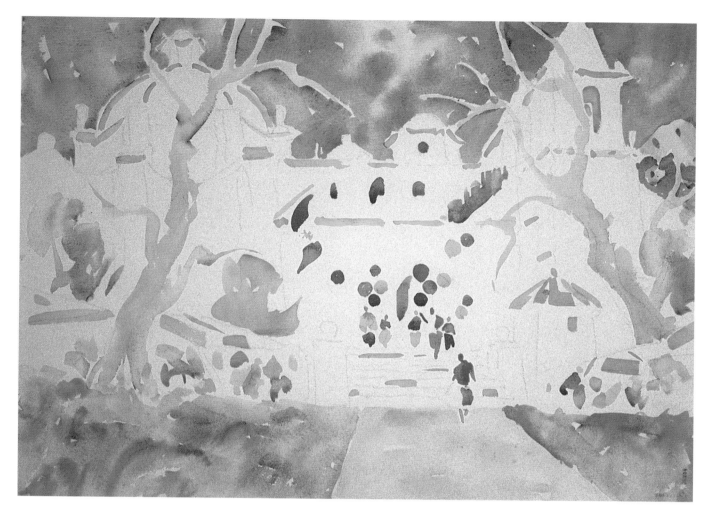

3 Middle Values

From tray 2, put in wet-on-wet small amounts of Aureolin and lean Permanent Rose with large amounts of Cobalt Blue for a predominantly cool sky. Try to have a value gradation from left to right and top to bottom, and paint negatively around the church and tree limbs that extend into the sky. For a predominantly warm foreground, first put in a few little strokes of Cobalt Blue and/or Viridian, and then come in wet-on-wet with big strokes of Aureolin and lean Permanent Rose. If it's too warm, drop in some more Cobalt Blue and Viridian.

> A picture is something which requires as much knavery, trickery and deceit as the perpetration of a crime.
>
> —EDGAR DEGAS

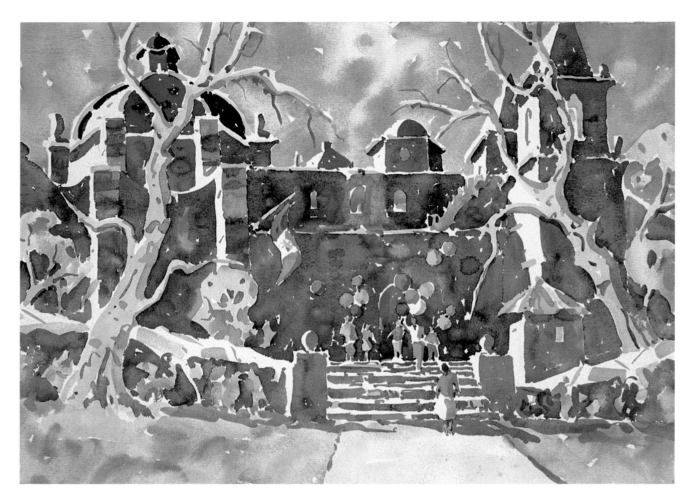

4 Dark Values

Put in all of the large darks using combinations from trays 3 and 4 wet-on-wet, and remember to paint negatively around saved whites and saved color. Start with the dome (upper left). Use mostly Phthalo Green, and drop in a little Alizarin Crimson. Moving downward and to the right, use combinations of Ultramarine Blue and Alizarin Crimson for the buttresses and Ultramarine Blue and New Gamboge with a little Alizarin Crimson for the church. Drop in some Phthalo Green and Winsor Yellow and very small amounts of Cadmium Scarlet and Cadmium Yellow. Use Ultramarine Blue and New Gamboge for the steps, columns and small building at the right and Ultramarine Blue and Alizarin Crimson around the figures under the awnings.

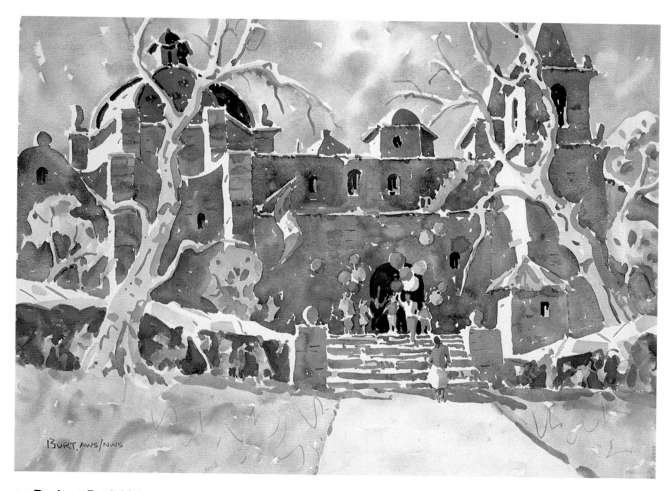

5 Darkest Dark Values

These final colors from trays 3 and 4 only take minutes to do, but they bring the drama of the painting to a climax. Use Phthalo Green and Alizarin Crimson on the right side of the dome at upper left. Accent the orange buttresses on top of the dome with Alizarin Crimson, but don't accent the ones on the left side of the dome. Accent the small dome on the right in the same way. Also accent with Alizarin Crimson the saved light orange and saved white horizontal and oblique lines that outline the church. Accent the windows and doorways with Phthalo Green and Alizarin Crimson. Make the main doorway at the top of the stairs the darkest. Put in the darks of the awning at lower left and right by using Alizarin Crimson and Ultramarine Blue, but don't make it as dark as the main doorway. Then paint in the darks of the flag using Phthalo Green and Alizarin Crimson.

THE MEXICAN BALLOONISTS
22″×30″ (56cm×76cm)

Give In to Your Surroundings

This New Orleans street scene owes its success in part to a smaller on-location painting I did there during Mardi Gras. I set up on a corner on Dauphine Street and was instantly surrounded by the vibrations of the city. My imagination was still receiving a mind's-eye view when I got back to work in my studio. The painting vibrates with intense colors and their opposites. The figures appear to be moving. It's a good combination of hard edges and wet-on-wet mixing. The paint just seemed to want to do all the right things!

MARDI GRAS FEVER
30″ × 22″ (76cm × 56cm)

FULTON BOATSCAPE
20″ × 16½″ (51cm × 42cm)

Don't Be Afraid to Crop

The concept for this painting came from many trips to the Texas gulf coast and owes part of its success to cropping out and discarding parts that were less than successful. That's the way of painting: Take what you get and be thankful. Other factors contributing to its success are the decisive, spontaneous, clean strokes done without hesitation, the vibration of the complementary pairs red and green and blue and orange, the textural effects, the movement and, of course, happy accidents. It reads as a hot, sunny day at the boatyard. I would have liked it better had there been more saved white on the middle figure and a cleaner, more intense green on the right figure, which is almost lost in the dark.

Afternoon in Cesi

Pronounced "Cha-sey," this beautiful hill town in southern Umbria has the most wonderful switchback road used to gain access to it, which lent itself to a rhythmic diagonal and S type of composition. Colorful signs also contributed to the concept. This painting is yet another example of rearranging, improvising and composing. There was good value contrast caused by the sunlight and shadow, but the shapes had to be redesigned for variety's sake. The road goes up from left to right, so I changed the background mountain to go down from left to right, for conflict in direction. The figures, tree shapes and colors were all improvised.

Afternoon in Cesi is a success because it has unequal measures in all the elements of design, and it has unity, harmony, balance, conflict, dominance, alternation, gradation and repetition. The diagonal is the dominant type of composition, with S, grouped mass and allover pattern influences. Notice how I deliberately leaned the trees into the painting to lead your eye back into the action. The pattern scheme is big darks and small lights against middle values.

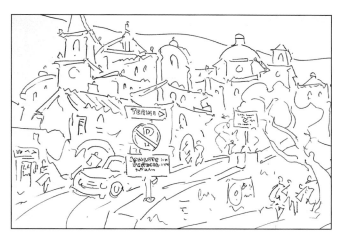

Sketch
A light and loose pencil sketch provides an incentive to keep the painting loose and suggestive. I exaggerated the diagonal and S shape of the road.

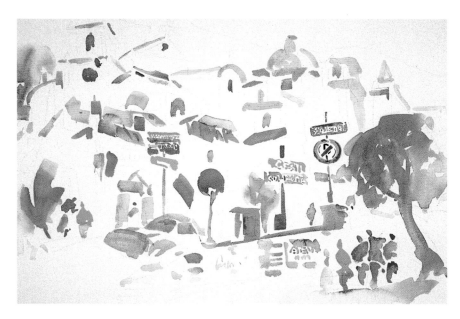

2 High-Chroma Color With Opposites

Use Scarlet Lake with a touch of Cadmium Yellow with Cobalt Blue for an opposite, Cadmium Scarlet with a touch of Opera and Phthalo Green for an opposite and Aureolin and Cobalt Blue with Permanent Rose as the opposite. Don't allow them to mix wet-on-wet. Use these combinations for the signs plus combinations from tray 2. Use Cobalt Blue with Permanent Rose for the car. For the roofs and outlines of the buildings, use Scarlet Lake with Cadmium Yellow, and Cobalt Blue for their opposite. For the trees, use a wet-on-wet mixture of Viridian and Permanent Rose, with Aureolin added to the one at top left.

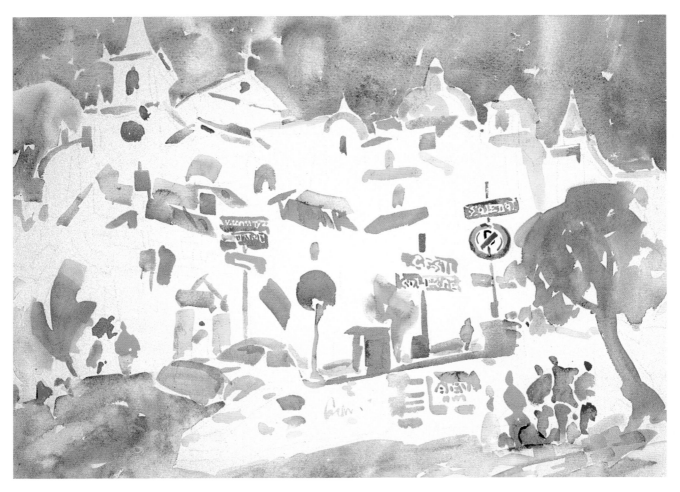

3 Middle Values

From tray 2, put in a few small pieces of Aureolin and Permanent Rose and large pieces of Cobalt Blue for the sky, allowing them to mix. For the foreground, put in a few small pieces of Cobalt Blue and/or Viridian, and lay in large pieces of Aureolin and lean Permanent Rose, letting them mix. Remember to paint negatively around saved whites and other saved color.

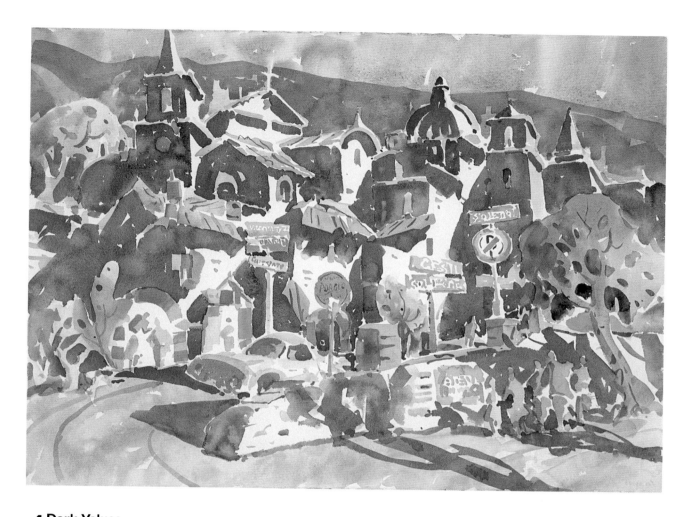

4 Dark Values

Using the puddles on trays 3 and 4, paint in wet-on-wet the diagonal symbol for the mountain behind the buildings with Ultramarine Blue. Notice how the cool sky from step 3 makes it appear grayed. Once dry, use Ultramarine Blue for cast shadows in the lower sections of the painting. Drop New Gamboge into the Ultramarine Blue to gray the cool side of white buildings, and drop very small amounts of Cadmium Yellow and Cadmium Scarlet into this mixture to add variety to them. Don't be timid with the darks. Make them darker than the middle values in the foreground and darker than the mountain behind.

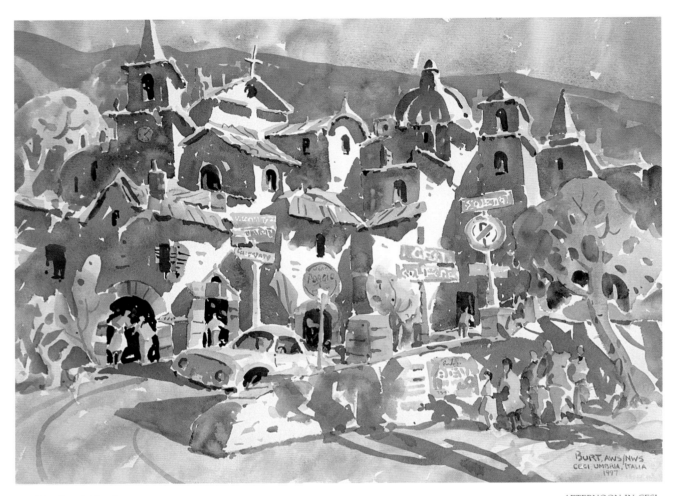

5 Darkest Darks
Use Phthalo Green and Alizarin Crimson in a rich state for windows, doorways, accents on the car and especially around the two dominant figures in the doorway at lower left. Use Ultramarine Blue, Alizarin Crimson and Phthalo Green separately to accent figures at lower right.

AFTERNOON IN CESI
22″×30″ (56cm×76cm)

Change Shapes and Improvise

This painting comes from an earlier on-location painting I created one hot summer day in a historic district in San Antonio, Texas, called La Villita [Vĭ-Yee-tah]. I used an old house there as a point of departure. I changed some shapes to get away from being boxy, and improvised the figures, foliage, trees, sky and foreground. The concept was triggered by the unequal measures of dark and light and by an almost triangular look. There was a diagonal and grouped mass influence. The design would have been more effective had there been saved whites on the figures and if the other figures by the left sign in the doorway weren't lost from lack of contrast. One of the signs says "La Villita Art Gallery." The other says "assistance for the poor." Rather ironic, for by the time I quit painting and got in out of the heat myself, *I* needed assistance.

THE ART GALLERY
22″×30″ (56cm×76cm)

THE YELLOW HOUSE
15″×22″ (38cm×56cm)

Be Open to Unexpected Changes

This work is of the same vintage as the previous piece and was done with the same palette and approach. The subject of the painting, an old house, was located in Boerne, Texas. What originally got my attention was a group of white chickens and a colorful rooster in the yard. But by the time I got set up, they were gone. Suddenly, I noticed the sunlight hitting part of the house and the roof. Shadows from the trees made a diamondlike setting for the light. I moved some of the trees around and changed their shapes to help the design. The background positive tree pushes out the light roof and one of the chimneys. The biggest compositional influence is the tunnel-like enclosure made by the trees. There is also a diagonal influence. The tree symbols have good variety in that some are full and some are sparse. In reality, this yellow house is stone, but the vertical lines suggest that it is wood.

Mexicoscape II

There is never a statute of limitations on concepts. The one for this painting, for example, took a while to germinate. Originally, it came from an on-location painting in the silver mining town of Mineral de Rayas near Guanajuato, Mexico, but it slowly evolved into what you will paint here. It was the vertical height and monumental look of the buildings that originally caught my attention. In actuality, the bell tower was the same height as the dome, which made equal measures. The shape also looked too fussy or ornamental. All the symbols were improvised, and the church in the far right background was added for repetition of the main dome and for informal balance. The main dome was given dominance in height, and the negatively painted tree symbols were given a large role in the design.

Sketch
The design has taken on a triangular shape in this stage, the top of the dome being the apex of the triangle. I massed in the tree symbols because trees end up looking disunified, disconnected and too busy when you put in millions of leaf shapes.

A work of art is a symbol. You do not paint things, but the forms of things. You cannot create skies, grass and birds, but you can create symbols that evoke those things. Your painted symbol should not try so much to be a bird, but rather it should try to say bird. Painting is a visual language with it's own syntax, and you must become fluent in that language.

— FRANK WEBB

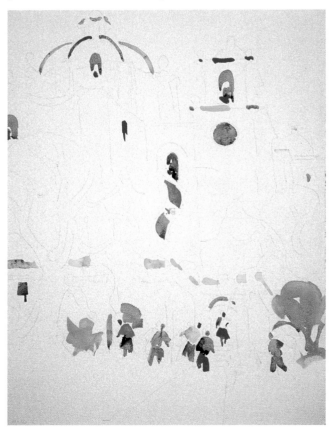

2 High-Chroma Colors With Opposites
Without mixing, put down pure, clean colors and opposites from trays 1, 2 and 4 for the figures, flag, doorways, windows and the outline of the church. For the clock symbol on the bell tower at upper right, use colors from tray 2 and allow them to mix wet-on-wet.

3 Middle Values

Using colors from tray 2 wet-on-wet, put down lean Permanent Rose, Aureolin and Cobalt Blue for the sidewalk. For the sky, put down pieces of lean Aureolin and Permanent Rose, and then put in larger pieces of Cobalt Blue and even a little Viridian. For the foreground, put down a little Cobalt Blue, and then put in a large amount of lean Aureolin and Permanent Rose. At the same time, use Aureolin, Permanent Rose and Viridian from tray 2 and paint in the tree symbols wet-on-wet so that the left tree connects with the foreground. Use more Aureolin for the left tree and more Permanent Rose for the one on the right.

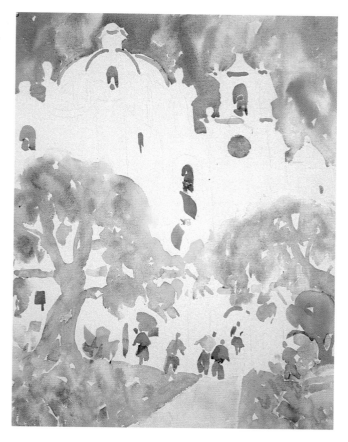

4 Dark Value

Start at the top left and work your way down with clean color from trays 3 and 4. For the dome, use Phthalo Green with a small amount of Alizarin Crimson dropped in (make sure it's darker than the sky). Put some very small specks of Cadmium Scarlet and/or Scarlet Lake and Cadmium Yellow into the saved whites.

Without mixing, use Alizarin Crimson and New Gamboge with Ultramarine Blue for the buttresses, and use a variety of proportions of these colors for the other darks. Drop in Phthalo Green and Winsor Yellow wet-on-wet, plus a few specks of the cadmium hues. As you come down, punch different size dark shapes and directions into the tree shapes. For variety, use Ultramarine Blue and New Gamboge in the lower part around the figures, again with a few specks of the cadmium hues. Do the same with the background church at the upper right, but make it slightly lighter. Put in a few strokes of Ultramarine Blue to define the sidewalk, and put a few calligraphic strokes of Alizarin Crimson in the foreground to add rhythm.

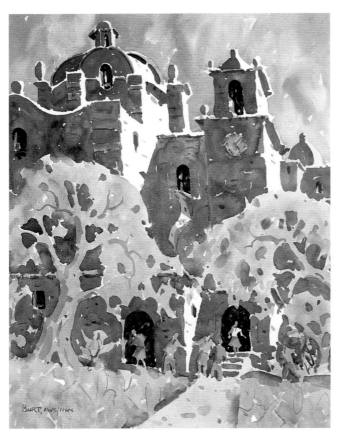

5 Darkest Darks

Use rich Phthalo Green and Alizarin Crimson from tray 4 for windows and doorways, especially for the door on the lower right that pushes out the senorita. She has become the focal point because of complementary colors, darkest darks and saved whites. For the left side of the dome, use a leaner mixture of these same colors.

MEXICOSCAPE II
30″×22″ (76cm×56cm)

Save What You Like Best

Cropping is always legal, and in this case, it saved a painting. This small piece is what remains from a larger one done on location in southern Spain. *El Estacion*, as you might guess, means "train station." It was clear and sunny, and no one bothered me as I painted. On the contrary, the stationmaster's wife was singing a song from an Italian opera—an unexpected pleasure. Though the concept for the painting came from value contrast, it may have been helped along by listening to the senora's beautiful voice.

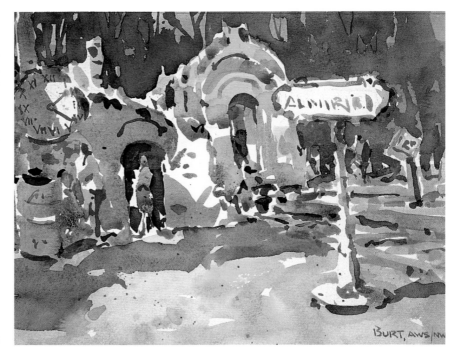

EL ESTACION
14″×18½″ (35.5cm×47cm)

Fisherman's Delight

The original idea for this painting resulted from seeing boats grouped together on the waterfront in Naples, Italy. As is always the case, I changed shapes, directions, colors and values to suit my own purposes. There actually was a castle nearby in the Bay of Naples, but it didn't look like the one you see here. I put it in the top right to change the direction of the diagonally shaped buildings in the foreground and to put more weight in the upper part of the painting.

This painting has unequal measures in line, value, color, texture, size, shape and direction. It has un-usually good conflict in direction. The main boat at left is stopped by the second green boat going the opposite direction. It in turn is intersected by another boat going back into the painting. The oblique shapes of the buildings going from left to right are slowed down by the intersecting vertical shapes of the masts and the castle at the right. The overall oblique shape has boats that interlock, overlap and have good variety in size, shape, value, color and direction. The major compositional scheme is diagonal. There is a strong grouped mass influence. There are also S, radiating line and tunnel influence.

Sketch

You probably know by now to make your sketch very light and loose using a 6B pencil. Never have it look as it does here.

2 High-Chroma Colors With Opposites

By now, you should be able to see the different high-chroma colors and opposites from trays 1, 2 and 4 without having me call them out. The various hues of orange come from Cadmium Scarlet and/or Scarlet Lake and Cadmium Yellow, the blue is Cobalt Blue, the yellow is Cadmium Yellow, the purple is Permanent Rose and Cobalt Blue, the red is Cadmium Scarlet or Scarlet Lake with some Opera dropped in and the green is either Phthalo Green or Viridian. Remember, as always, there is little or no wet-on-wet mixing in step 2.

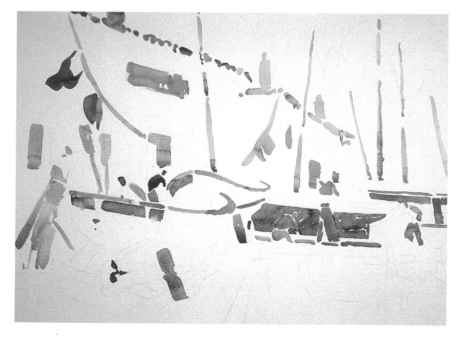

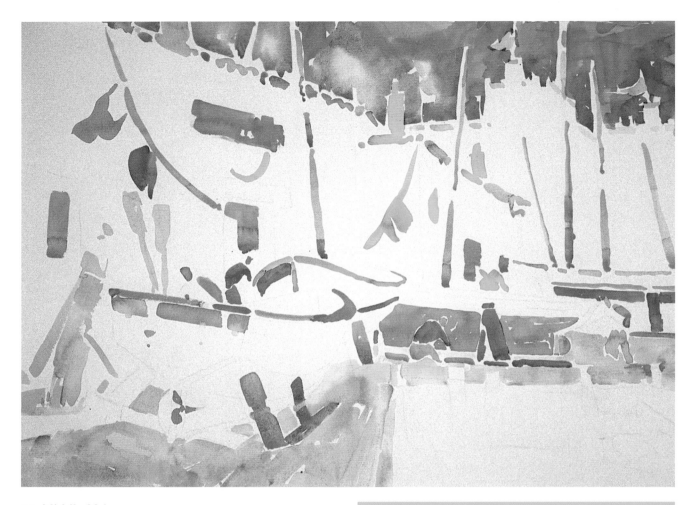

3 Middle Values

As usual, use tray 2 above and below for the wet-on-wet middle values. The cool above will need some warm in it, and the warm below will need some cool in it. You want these middle values to be darker than the light values that precede them and lighter than the dark values that follow. If you have to put another layer over this one to darken it, or if you have to lift out some color to lighten it, you'll end up losing some clarity, transparency, cleanness and spontaneity. When you've lost those qualities, you've lost watercolor's main attraction. Be aware of this as you work around the negative painting involved in this and especially the next step.

Roll With the Punches

It was a sunny, delightful day when I set up my easel and equipment to paint this scene for the first time. The fishermen had seen painters before, and they didn't seem to mind being the subject of my work. Everything went well, and I was pleased with the result. As I was cleaning up and putting my equipment away, I noticed a large dog watching me. Actually, I saw him earlier in the day; he belonged to one of the fishermen. I sensed an urgency about getting my equipment put away quickly. Well, I turned my back on the dog for just a second to put my easel away. When I turned back, he was sniffing the painting, which was propped up against a boat. Before I could open my mouth to say no, he raised his leg on it. It's bad enough to get a critique from a dog, but for him to give it that negatively is unforgivable. I gladly gave the painting to the dog's owner. I just hope he aired it out before he had it framed!

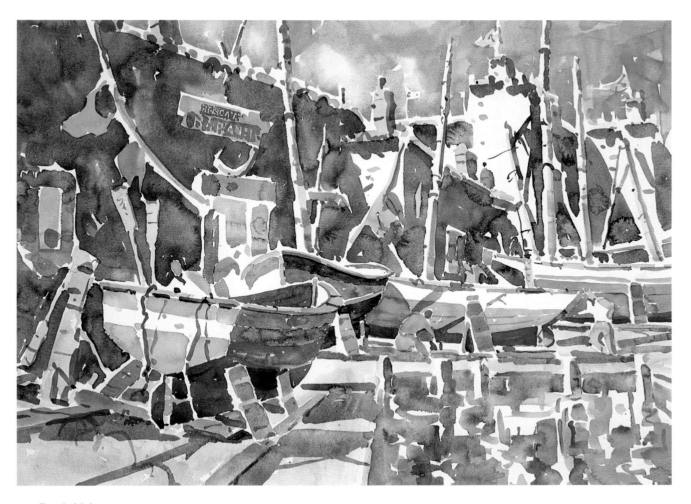

4 Dark Values

Paint in your dark values, and use a big flat 1½-inch (3.8cm) brush to increase the fun and spontaneity of painting. Why? Because bigger brushes naturally hold more pigment and water and enhance paint quality. Small brushes don't put enough paint down in larger areas for wet-on-wet mixing to occur.

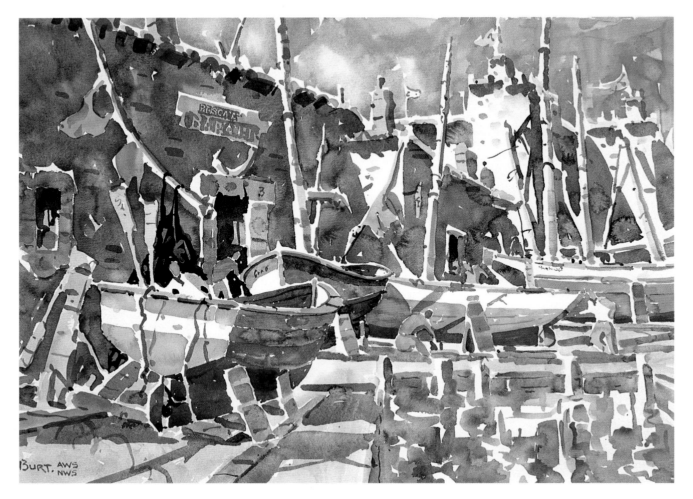

5 Darkest Darks

This is the easiest step and the reward for your patience. These darkest darks from trays 3 and 4 really look good and tie the whole painting together, but they would be useless without all the more difficult work you did in the previous steps. Use care, however, in punching out the main character with the rich Phthalo Green/Alizarin Crimson mixture. Use less water to keep these darkest darks as rich as possible.

FISHERMAN'S DELIGHT
22"×30" (56cm×76cm)

Use Temperature Extremes for Variation

This detail from a painting done on location in downtown New Iberia, Louisiana, is just what the title implies: extremes in temperature. It goes from cool to red hot. I don't know why I made such temperature extremes. Maybe I had too much Tabasco sauce in my Cajun shrimp gumbo for lunch! But whatever the reason, I like the end result. You sure can't say that it's boring. The red-hot red is Cadmium Scarlet with a little Opera dropped in.

EXTREMES (DETAIL)
5″×8½″ (12.5cm×21.5cm)

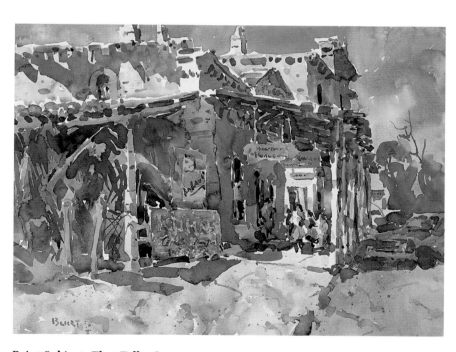

INGENHUETT'S STORE
22″×30″ (56cm×76cm)

Paint Subjects That Tell a Story

Ingenhuett's Store, the subject of this painting, opened in 1867. It is the oldest store in Texas and one of the oldest in the U.S. Gregory Krauter, the current owner, tells of his Great-Grandmother Ida Ingenhuett looking out an upstairs window of the store in 1892 and watching Pancho Villa water his horses. He offered to pay for the water, but the Ingenhuetts graciously said no.

This painting is an older work. It's more muted and grayed than my present paintings, but I like the way it works. It has unity, harmony, balance, conflict, dominance, alternation, gradation and repetition in all of the elements of design. The main compositional influence is the tunnel that encloses the figures. There are also strong diagonal, radiating lines and grouped mass influences. The pattern scheme is large darks and small lights against mid-values. If you're ever near Comfort, Texas, make a point to drop by and see this old store. It has a lot of charm inside and out and is well worth the trip.

Umbrian Delight

The concept for this painting came from yet another delightful sunny day in another beautiful Umbrian hill town. The town was made even happier by a wedding. As you work this painting, keep your colors especially clean and crisp and your darks clean and transparent to get that happy, lively feel. Relate your grayed wet-on-wet midvalues to enhance the saved colors and saved whites.

1 Sketch

Sketch your composition light and loose. Mine was taken from a smaller on-location sketch, with several design changes made from the original. Don't be afraid to change things as you work. It's easier to make painting changes when you're not tied down to a rigid drawing.

> As a painter, my color is my language, my brush is my voice and my finished painting is my testimony.
>
> —BETSY DILLARD STROUD

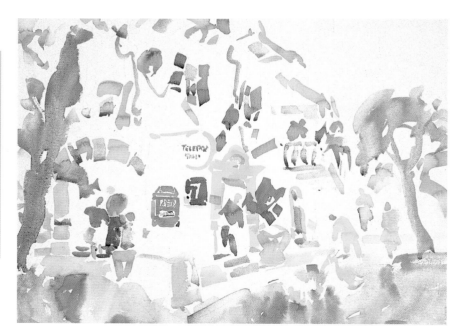

2 High-Chroma Color With Opposites

Use the same procedure as in all of the previous demos, but with one exception. Start with trays 1, 2 and 4 for all the intense color, and allow the colors from tray 2 for the tree symbols to mix. But now, put down your foreground midvalues from tray 2 wet-on-wet instead of waiting until step 3, because you want those values to join with the tree symbols.

3 Middle Values
Put in the sky middle values wet-on-wet from tray 2. Take care to negatively paint around the castle and the building.

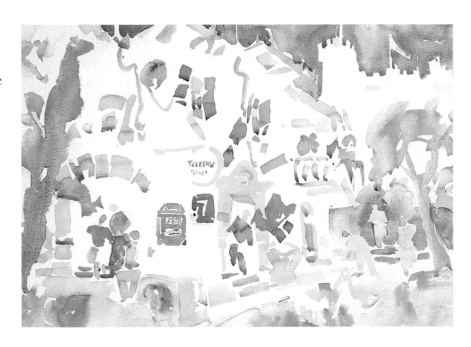

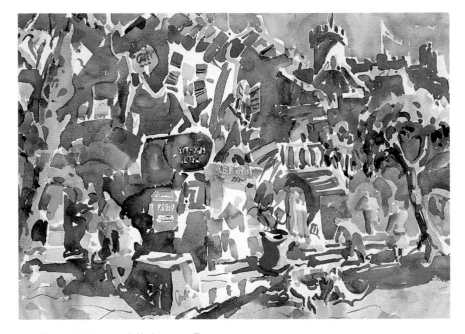

4 Dark Values—Mixing on Paper
For the dark sign at left, use Alizarin Crimson and Ultramarine Blue with Cadmium Yellow dropped in. For the cast shadows in the foreground, use pure Ultramarine Blue (it will appear grayed because of the warm middle value underneath). Paint in the dog symbol using Ultramarine Blue with New Gamboge to accent it to break up the too-regular triangular shape at lower right. Notice how, once the trees are accented by a Phthalo Green/Alizarin Crimson mixture, they transform from positive into negative shapes as they are pushed forward by the darks.

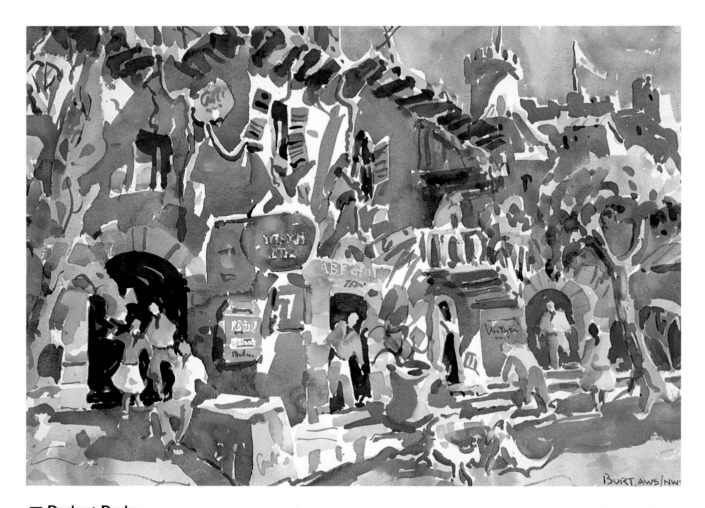

5 Darkest Darks
Use rich Alizarin Crimson and Phthalo Green to punch out windows, eaves, shutters and figures in doorways. My original intention was to make the three joined figures in the left doorway the focal point. However, they seem to be competing with the lone figure in the center doorway for that honor.

UMBRIAN DELIGHT
22″ × 30″ (56cm × 76cm)

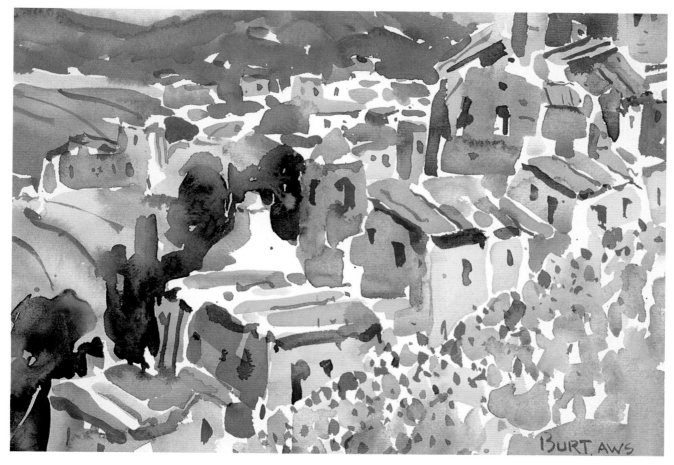

Realism or Mind's-Eye View?
This small studio piece resulted from an on-location painting in southern Spain. Though the original painting was more realistic, I prefer the more artistic studio version you see here. It's much more fun to break the chains of the model than to copy. These "imagination-scapes" that are hatched from on-location paintings frequently take time to germinate. They evolve by making a translation from the real to the imagined, and they require you to compose and rearrange all of the things that you see into a good design. Composing and arranging is artistic and fun. Copying is not.

ANDALUCIAN SPRING
11″×15″ (28cm×38cm)

The Road to Valle Di San Martino

This painting differs in type of composition and in pattern from most of the other paintings in this book. It's closely related to the three spot, but it's actually a four spot. Notice how your eyes go from town to town in a circular way, so it also has aspects of the circular type of composition. It has an allover pattern scheme. See how the foreground, middle distance and far distance are all predominantly warm? If I were to do this painting again, I would cool down some of that warm pink.

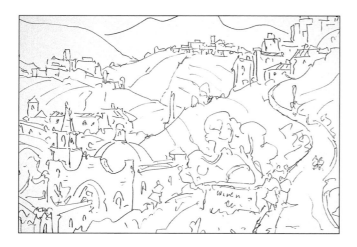

Sketch

2 High-Chroma Colors Plus a Few Middle Values

This painting differs from most of the other demonstrations in that now a few of the middle values for the foreground, road and middle and far distances are painted using tray 2 rather than waiting until step 3. Also, paint in the darker middle values for the building symbols now as well in order to gain some consistency in the painting and to nail down the size, shape and locations of trees, figures and fields early on.

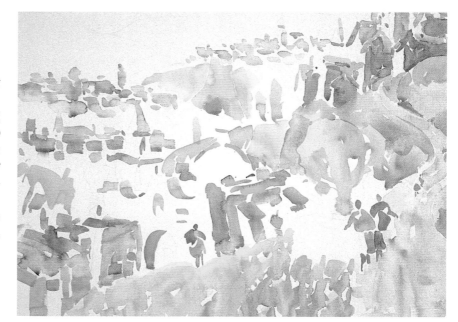

3 Remaining Middle Values

Use tray 2 to paint in the remaining middle values, including under the tree at lower right, to the left of the church at lower left, below the distant town at upper left, below the far distant tree at upper right and all of the sky.

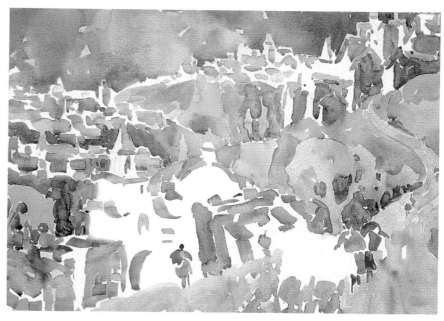

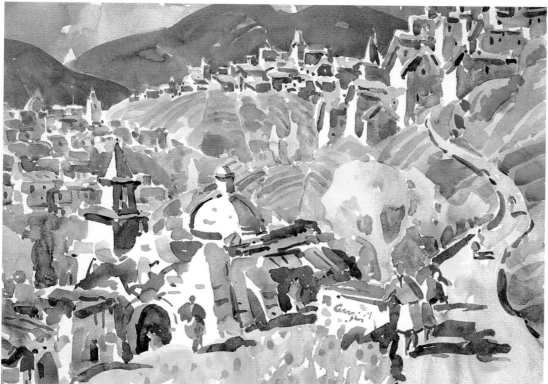

4 Dark Values

Just as in the previous demonstrations, paint in your darks with colors from trays 3 and 4. Use the illustration here as your guide to their placement.

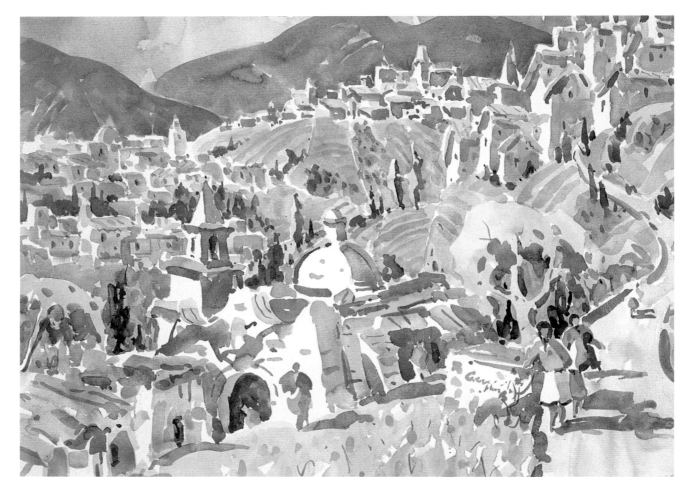

5 Darkest Darks

Use all of the intense colors and opposites from trays 1, 2 and 4 without mixing to create your darkest darks. Paint in the mountains with Ultramarine Blue, the dark side of the church with Ultramarine Blue and New Gamboge, the cast shadows with Ultramarine Blue, distant trees with a mixture of Phthalo Green and Alizarin Crimson, and the dark accents on the figures either with Alizarin Crimson or Phthalo Green. Paint the dark shadows of the trees with a mixture of Phthalo Green and Alizarin Crimson.

THE ROAD TO VALLE DI SAN MARTINO
22" × 30" (56cm × 76cm)

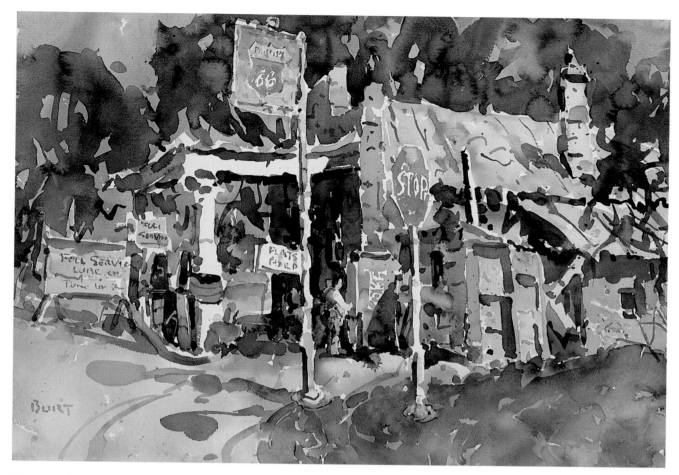

Use Gouache in an Emergency

This older "imaginationscape" was triggered by value contrasts and interlocking, overlapping shapes, both real and imagined. It is a rare instance where I used a little gouache to correct an otherwise successful design. I had lost the saved white and the saved color on the figure by the Coke machine and on the sign at top left, so I used gouache to bring them back. I don't like doing this, but extreme emergencies call for extreme measures. The figure would have been better had I used pure white gouache on the upper part, which would have given it more importance. But even with this fault, the painting vibrates with energy, movement, color and color opposites. Those dark, transparent tree symbols behind the service station make it appear dramatic. The signs have been thrown a little out of focus, but you can still imagine what they say. The main compositional influence is a tunnel, and there are triangular, grouped mass and radiating line influences.

FULL SERVICE
22″×30″ (56cm×76cm)

Boatyard Action

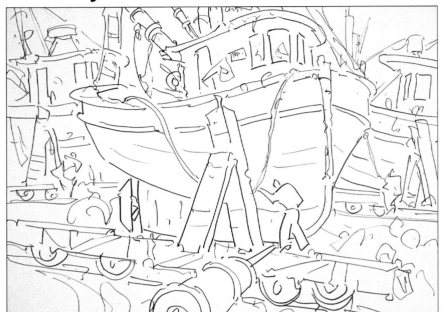

Sketch
As usual, sketch out your composition light and loose.

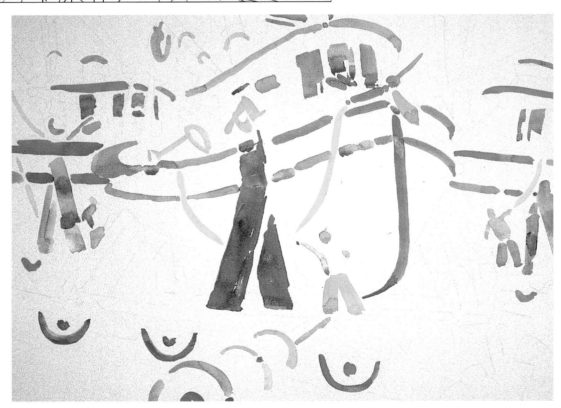

2 High-Chroma Color With Opposites
Put in reds, oranges, yellows, blues, greens and purples from trays 1, 2 and 4. Allow nothing to mix except for the dark green buttress supporting the boat. Paint the buttress using Phthalo Green with Alizarin Crimson dropped in wet-on-wet. Remember that though it looks too dark now, it won't in the end.

3 Middle Values

Put in all the middle values above and below using tray 2 wet-on-wet. Make the cool middle value sky darker than the warm middle value below. The darker sky pushes out the saved whites and colors while the lighter foreground makes the dark boats more emphatic.

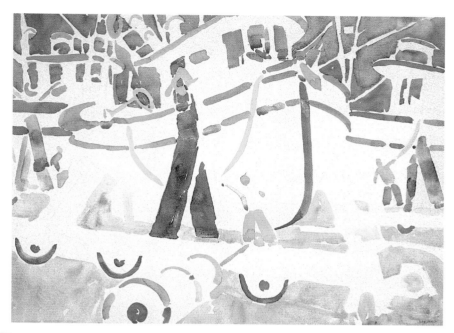

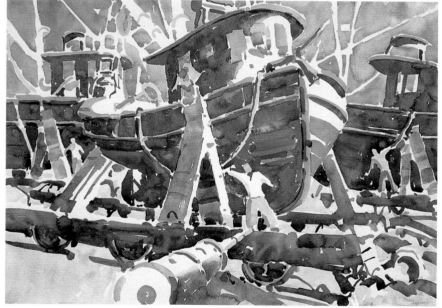

4 Dark Values

Starting with the background boat on the left, use Ultramarine Blue and New Gamboge and drop in small pieces of Cadmium Scarlet and Cadmium Yellow before it dries. Use Phthalo Green and a touch of Alizarin Crimson for the lower hull. Then repeat the process for the other background boat on the right.

Put in the dark of the oblique support below the main boat using wet-on-wet combinations from trays 3 and 4 plus small bits of the cadmium hues. Put in the big dark red on the lower part of the main boat using mostly Alizarin Crimson, and drop in some Ultramarine Blue and a small amount of Phthalo Green and Winsor Yellow wet-on-wet.

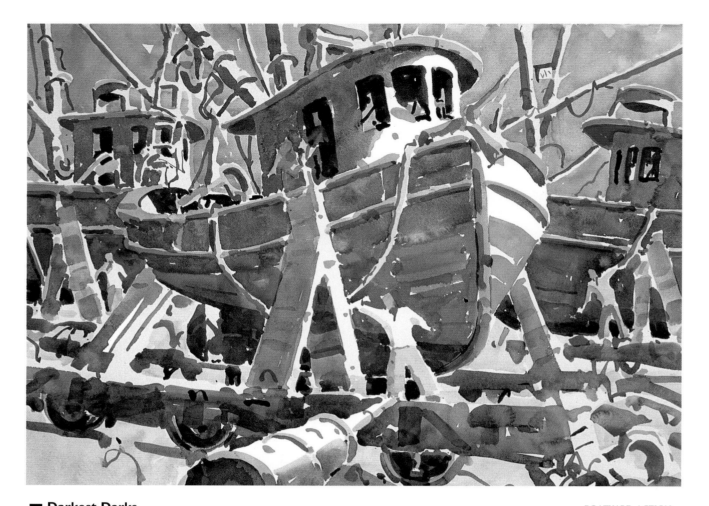

5 Darkest Darks
Use rich Phthalo Green and Alizarin Crimson from tray 4 for windows, the lower parts of the right and left boats, and the round tubular shape below the main boat. Use Ultramarine Blue and Alizarin Crimson from tray 3 for the lower part of the main boat and the dark sides of the rigging. Remember to make all of the darkest darks on the main boat darker than those on the background boats. Force yourself to make these strokes darker than the other darks to accent the focal point (the foreground figure).

BOATYARD ACTION
22″×30″ (56cm×76cm)

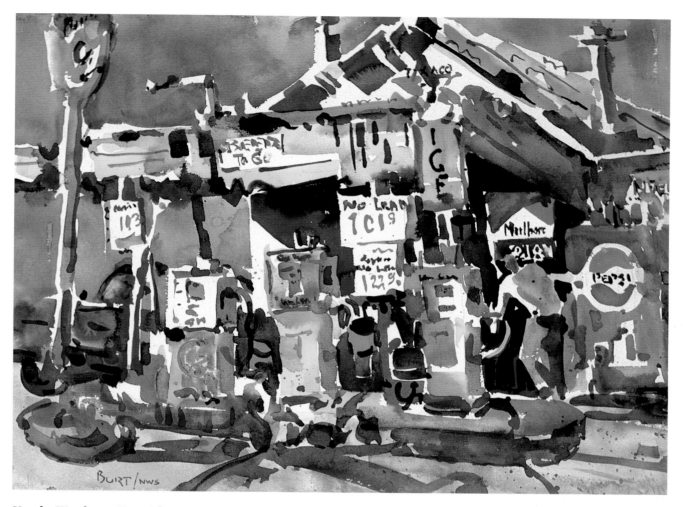

Use the Weather to Your Advantage

This painting, done in the old part of Kerrville, Texas, might be called a "signscape" since the signs played a major role in the production. It was done on a dry, windy, blistering hot day. I was set up across the street in what little shade there was. I completed it in record time just to get out of the heat. Everything was hot—the weather, me and the color I used in the signs, pumps, station, sky and foreground. You can see that the puddles were clean because the color is very pure. The problem was getting strokes down quick enough to mix with other strokes before they dried in the wet-on-wet sections. It was like working under a nonstop hair dryer. In cases like this you have to do something even if it's wrong. It would have been an impossible task without the puddles.

FULL SERVICE II
22″×30″ (56cm×76cm)

Bella Italia

The concept for this painting resulted from seeing a tunnel exit in the beautiful medieval town of Castel Di Lago in southern Umbria. Like *The Road to Valle Di San Martino* back in Demo 9, this painting varies a bit from the normal progression, so pay close attention as you go through each step.

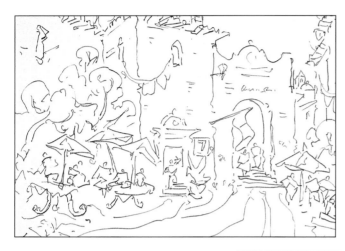

1 Sketch

Once again, sketch your main compositional elements. Keep your sketch light so that you are never tempted to use it as a coloring book.

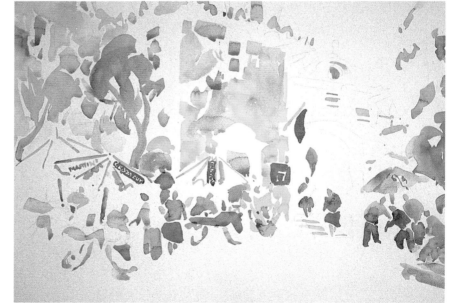

2 High-Chroma Color and Wet-On-Wet Mixing

Just as in the previous demonstration, the sequence differs a bit in that both high-chroma colors with opposites and wet-on-wet mixtures are both used at this time. Without mixing, put down the intense colors with their opposites from trays 1, 2 and 4 for symbols such as flags, figures, umbrellas, signs, tables, etc. Next, use just tray 2 for the figures on the right, the tree symbols and the building at center and left, and let some mixing happen. Notice that the building is predominantly Aureolin with a little Permanent Rose and Cobalt Blue. For the intense colors, use Cadmium Scarlet (and/or Scarlet Lake) plus Cadmium Yellow for the orange, Cadmium Scarlet plus a touch of Opera for the red, Phthalo Green for the green, Cadmium Yellow for the yellow and Permanent Rose plus Cobalt Blue for the purple.

3 Middle Values

Make the cool middle value above darker than the warm middle value below. Put down a little Aureolin and Permanent Rose for the sky, and then come in with the predominant Cobalt Blue wet-on-wet. Do the opposite below; first a little cool and then the predominant warm.

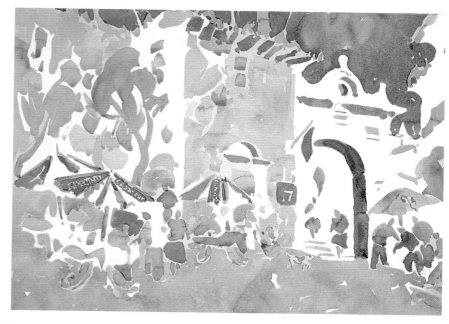

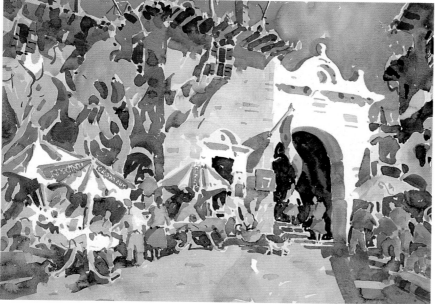

4 Darks and Some Darkest Darks

Notice here that some of the darkest darks are put in at approximately the same time as the darks in order to gain consistency and spontaneity. Take more care in the negative painting during this step. Use tray 3 for the building shadows, cast shadows and eaves. Use more Alizarin Crimson on the right-hand building and mostly Ultramarine Blue and New Gamboge for the other buildings, cast shadows, windows, doors and as punchouts for the figures. Make the window and door symbols darker. For variety, sprinkle in a little bit of the cadmium hues wet-on-wet. Also use Alizarin Crimson, Ultramarine Blue or Phthalo Green separately for the shadow sides of figures. Use a richer Phthalo Green and Alizarin Crimson around the flag and focal point.

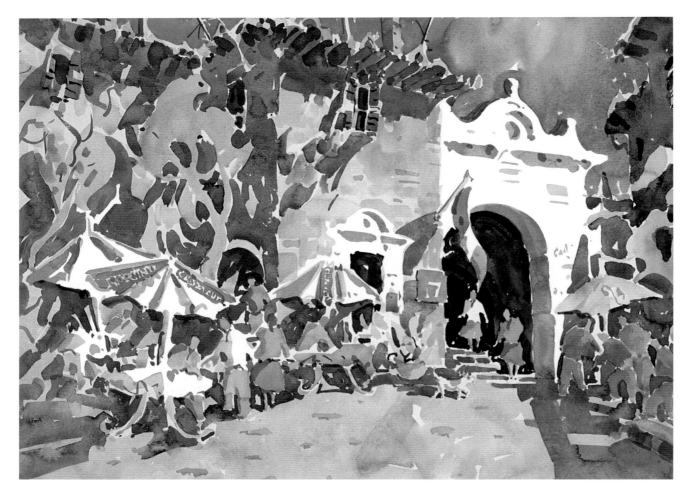

5 Darkest Darks

I did something here that I ordinarily don't do. Notice in steps 2, 3 and 4 that the front of the sunlit building in the center is very light—so light that it weakens the arched tunnel. There was not enough value contrast, so I used a lean combination of Permanent Rose and Aureolin (mostly Permanent Rose) over it and it worked. Now both it and the saved white are strengthened. It didn't turn muddy because the lean wash was the same as the colors underneath.

Put in some final darkest dark accents with Phthalo Green and Alizarin Crimson around the figure under the flag, and put an accent of Ultramarine Blue and Alizarin Crimson in the saved white doorway to the left of the tunnel.

BELLA ITALIA
22″×30″ (56cm×76cm)

LAS MUCHACHAS
7″×5″ (18cm×12.5cm)

When It All Comes Together

It's fairly obvious that this small painting is a tunnel type of composition. That's what caused the concept. I improvised the color, figures, steps, darks and darkest darks. The color, value, texture, size, shape and direction have been given unequal measures. The cast shadow makes the top right different than the top left. The steps are different and unequal in size, shape and color. The figures are unequal in value, color, size and shape. They have movement due to curves and changes in size, shape, direction, value, color and texture. Even the darkest dark tunnel seems to move because of little bits of vibrant green. You can see four values here: saved white, intense color with opposites and other middle values, dark values and darkest dark values. This last step made it a vibrant painting.

Conclusion

In its simplest form, watercolor painting is merely depicting positive and negative space. Deriving pleasure from that depiction should be your desired end. Developing good technique, using clean color, practicing with enthusiasm and using your imagination are all means to that end.

From the very beginning, outfit yourself with everything you'll need or you'll end up handicapping yourself. Find yourself a good, stable easel, and buy good quality paints, paper and brushes. Buy a palette with deep wells to hold your paints. And though I hate to give diatribes and harangues over clean color, don't forget that clean water, clean brushes, clean palettes, clean pigment and clean puddles all add up to clean color.

Stopping to clean your palette and change the water is never wasted motion. Remember to wash out your brush before moving it to a different well or puddle, and always keep clean water over the pigment in the wells. It's a lot like working in a kitchen. You wouldn't cook in dirty, food-encrusted pots. Nor would you serve the food to your friends on plates caked with old food. It might poison them! At the very least it would taste terrible. The same holds true here: Dirty paint looks terrible.

Get acquainted with your friends, the pigments, and learn what they will do for you. Give them a chance and take some risks! Have fun, and be bold and decisive. Don't skimp on the paint or your paintings will look anemic. Use a bigger brush than you think you need for wet-on-wet sections. Let the paint mix on the paper for unexpected magic—you'll be surprised at how many times areas will paint themselves when allowed to.

Study the elements and principles of design and what they mean, as they will provide the foundation on which you will stand. Learn them as you go and make them a part of you. Keep them stored in your subconscious so you can use them as needed without having to actively think about them. After all, you'd never get any painting done if you just sat around worrying about rules! Besides rules, there are other important influences like imagination, intuition, memory and enthusiasm. These are priceless ingredients, and no work of art has been done without them.

Always paint what you like. Get your ideas or concepts any way you can. Observe, practice, experience and persevere. As Frank Webb once told me, "Art is primarily self-education. It proceeds by way of trial and error. You do not become a painter by graduating from a system of lessons, but by drawing and painting. If the class, book or video spurs you to draw or paint, well and good."

Pax E. Bonum

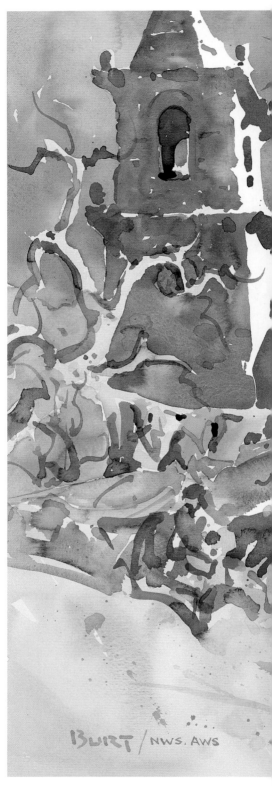

FIESTA FANTASY
22″×30″ (56cm×76cm)
Watercolor on Arches 140-lb. (300gsm)
cold-press watercolor paper

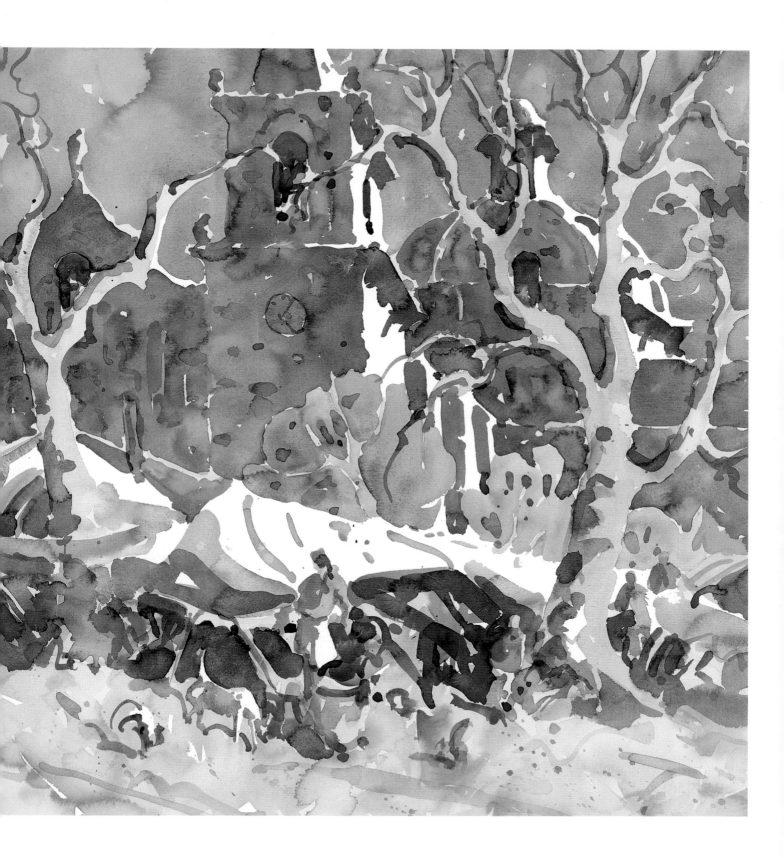

Index